POSTCARD HISTORY SERIES

Greenport

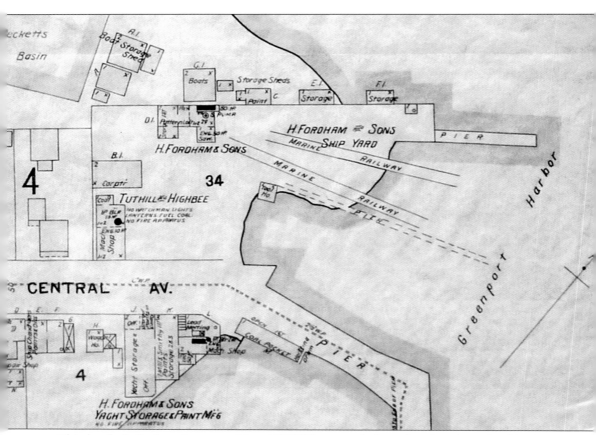

This detail of a Sanborn Insurance Map of 1897 illustrates the intensity of marine-related businesses on Greenport's waterfront. Since its beginning development of Main Street down to Main Street Wharf in 1827, it had become a full-service marine center. (Village of Greenport.)

POSTCARD HISTORY SERIES

Greenport

David S. Corwin and Gail F. Horton

ARCADIA
PUBLISHING

Published by Arcadia Publishing
Charleston, South Carolina

Printed in the United States of America

Library of Congress Control Number: 2013934058

For all general information contact Arcadia Publishing at:
Telephone 843-853-2070
Fax 843-853-0044
E-mail sales@arcadiapublishing.com
For customer service and orders:
Toll-Free 1-888-313-2665

Visit us on the Internet at www.arcadiapublishing.com

To John M. Montgomery (1936–2013)

CONTENTS

ACKNOWLEDGMENTS

Anyone we contacted in or about Greenport, Long Island, New York, eagerly responded to our requests for postcards, books, articles, or memories to help us ferret out and clarify the facts and issues needed to prepare for this volume featuring postcards of Greenport, and we give them heartfelt thanks for their information, support, and enthusiasm. We had a wonderful array of postcards to choose from, and due to all the support and oral interviews, we were able to assemble a near complete panorama of our community. We would like to thank Stanley Boyd, Jean and Michael Burden, Jacqueline Copas, Penny Coyle, Terry Keefe. Lisa Richland and the staff of the Floyd Memorial Library, Scott Gonzalez, Edward Jurczenia, David E. Kapell, Rev. Thomas LeMothe, Carla McMann, Jacqueline Monsell, Thomas Monsell, Jean Mellas Pitt, Sylvia Pirillo, Jim Sage, Norma Slavonik, Richard Sledjeski, Stirling Historical Society of Greenport, and Robert and Lillian White. Robert Bauman and Carlos DeJesus deserve special thanks for their proofreading and fact checking specifically. We also thank the following that contributed postcards to make this volume possible: Academy Printing (AP), Stanley Boyd (SB), Jacqueline Copas (JC), David Corwin (DC), Mary P. Coyle (MPC), Carlos DeJesus (CDJ), Floyd Memorial Library (FML), Gail Horton (GH), David E. Kapell (DEK), David Lish with Friends of Zaida (DL), Jacqueline Monsell (JM), Jean Mellas Pitt (JMP), Stirling Historical Society of Greenport (SH), and Robert White (RW).

INTRODUCTION

What better way to chronicle the history of the village of Greenport on its 175 years as an incorporated village than with a book that celebrates its spirited heritage through postcards? Early *postils*, without any image, were frequently used for brief messages from one town to another and were the telephones and Internets of the day. Robert White, a lifelong Greenport resident, describes the message he saw on a postcard his uncle Arthur White sent to relatives over in Good Ground (Hampton Bays) in the early 20th century, "Greenport is a nice place. The smoke rises straight from the chimney and the dogs bark at strangers." We agree with the quote and are pleased to present this collection of picture postcards culled from the collections of local people who value the view of their community through the lens of an outsider. They show the development of the village and surrounding area—its streets, landscapes, businesses, and waterfront—and many times, they catch an unexpected view that you never thought of as important or interesting until you see it through their eyes. In one instance, an area called Widow's Hole is featured in many different postcards, more than major, important subjects, such as the oyster industry, and you are soon off on a major research project, tearing through the microfiche copies of old newspapers, questioning old-timers, and looking through books and documents of the area trying to find out why Widow's Hole was so prominent and why was it called Widow's Hole?

The village of Greenport is located on the north fork of eastern Long Island and bordered by Fourth Avenue, originally named Germania Avenue, on the west; Stirling Harbor on the east; the waters of Long Island Sound on the north; and Greenport Harbor on the south. The Corchaug Indians were the original recorded inhabitants of the area. In 1639, Matthew Sunderland, in search of an area to harvest turpentine, was granted a patent by James Ferrette, the agent for the Earl of Stirling, William Alexander, to lands in Harshamomogue near Great Pine Swamp. This area is known as part of Greater Greenport. In 1640, Puritan minister Rev. John Youngs led a small group of followers across the Long Island Sound from New Haven Colony and founded the plantation here that was to become Southold Town, then spanning from Plum Gut to Wading River. Originally united with the New Haven Colony, after several changes of allegiance, it reluctantly rejoined the English Colony in 1674. In the period between 1662 and 1682, the Farms, the area around Winter Harbor (the waterfront portion of Greenport, so named because the waters never froze), was granted to Col. John Youngs, son of founding father Rev. John Youngs, and the white settlers farmed the area and developed a wharf on Stirling Creek accessed by a small road now known as Sterling Street. Local seafarers participated in the customary New England triangular trade, where rum was manufactured and shipped to the west coast of Africa

in exchange for slaves, who were taken on the Middle Passage to the West Indies where they were sold for molasses and money. Molasses was then sent to New England to make rum and start the entire system of trade again. Local fishing in the bountiful waters fed the area population. In 1687, Youngs sold a tract of 200 acres that was to become the basis of Greenport Village to William Booth. After being owned by several generations of the Booth family, the property was sold to Captain Webb, and upon his death in 1820, it was in lots of 10 to 20 acres to be used for agricultural purposes. This area, the site to become the village of Greenport, was, except for lots tilled for farming, totally unimproved. In 1827, work began to pave a main street down to the deep waters on the bay, and a port with wharfs at the end of Main Street and Central Avenue was established. Savvy Greenporters had noted the growth of the international whaling trade in the United States and the possibility for such trade in Winter Harbor, and they began to divide the area now known as Stirling Farms (in homage to William Alexander, the Scottish Earl of Stirling, who was the British recipient of the patent to Long Island during Colonial times) into small lots for streets, homes, and businesses. A large hill called Green Hill, where Greenport Yacht & Ship Building Co. stands today, was leveled to provide housing during the grading of the village, and Main Street was established reaching down to the deepwater port that included a marine railway, the hallmark of Greenport's continued success and vitality. Another marine railway was subsequently established at the end of Central Avenue. The citizenry began to meet in 1828 in the Clarke House, the newly constructed inn on Main Street, and they incorporated the village of Greenport in 1838: a 1.2-square-mile area bounded on the east by Sterling Creek, west by Moore's Woods, north by Kings Highway (Route 48), and south by Greenport Harbor. The diverse, vigorous community grew and prospered.

The village of Green Port, as it was originally spelled, consisted of the settlements of Winter Harbor, Stirling Farms, and Green Hill. Unlike the forests and farms of the unincorporated area around it, Greenport Village was developed on small lots and the stores often covered their entire lot. The only incorporated village in the town of Southold, and the second incorporated village in New York State, Greenport had a city-like layout, and its population expanded beyond the early English settlers to accommodate the diversity of new arrivals who came to work in the maritime occupations and later endeavors such as the railroad construction and brick making from the nearby clay pits. The subsequent congregations of the houses of worship reflect the diversity of the population influx of the different eras: Irish, Italian, black, Jewish, and German. By 1846, there were 250 dwellings, and in 1845, a fire department was initiated to protect the densely developed community of wood frame buildings.

When you study the postcards in this book, you will find several cards that reflect the architecture of the homes and businesses of the area. They spanned the style and scope of the prosperous whaling captains and business owners to the hardworking artisans and laborers who worked in the trades, on the water, and in the fields. If you walk the streets of Greenport today, you will see that many of these buildings are still here, and the history of the village can still be detected as you admire the rich variety of architecture of the homes, the wrought-iron fences and gates forged by local blacksmiths, the stepping stones and hitching posts from the days of the horse-drawn carriages, and the unique buildings made from the abundant bricks created from the rich, nearby clay pits at the local brickworks.

The area of Greenport outside the village was developed primarily in agriculture, including many farms, dairies, and a scattering of houses. The village, however, boomed as a shopping hub for Southold Town, with stores to satisfy the needs for those on land as well as those at sea. The large auditorium and opera house provided entertainment for the surrounding area and the polo grounds on Moore's Lane were popular for sports, circuses, and fairs. Maritime activities dominated the village and after the decline of whaling, Greenport-based coastal schooners busily traded goods up and down the northeast coast while others fished for oysters, menhaden, and other local fish and shellfish. Pleasure boats, both large and small, plied the waters of the deepwater port, and the area bred talented sailors from captains of large yachts and racing boats to kids in dingies and rowboats. Shipbuilding was a mainstay here, along with all the other necessary

marine mechanics and chandleries. Visitors, who arrived by boat, stagecoach, or train (if they were not passing through to take a ferry to another port), had splendid hotels and restaurants to tend to their needs. Workers looking for a place to stay could find a comfortable room in several of the boardinghouses located throughout the village. Forward-looking village leaders, in the late 19th century, built their own water, electric, and sewer facilities. A Works Progress Administration–funded sewer plant was added in 1938.

The picture postcards that emerged here in the later part of the 19th century featured a robust village with horse-drawn carriages on dirt roads. Early automobiles, paved roads, and sidewalks were a later addition. The narrow roads, created from streets of the horse-and-buggy era, bustled with activity.

Greenport was a patriotic community. The monuments dedicated to local soldiers who served their country from the Civil War through the Vietnam War feature prominently in the collections of postcards we reviewed. Culling old newspapers of the World War I and II period, you find reports of the overwhelming number local high school students who joined the armed services, the dedication of civilian volunteers on the home front both on land and sea, and the increased activity in the shipyards building military craft. The local economy boomed during this period, and between the two world wars, it also thrived as a result of the Volstead Act of 1920–1933, when Greenport Harbor became a center of the infamous illegal rum-running trade where many fortunes were made.

After World War II, the menhaden industry had a brief resurgence into the 1970s, but the loss of this activity, the arrival of fiber glass boats, and the development of shopping malls to the west led to the closing of many of the village shipyards and services as well as stores. As the need for workboats lessened, pleasure craft grew in importance.

There are a few of the once many farms left on the lands outside the village of Greenport; one is on Albertson Lane in Arshamomogue, and another has been developed as a vineyard on Route 48. After the World War II, pressure was put on the agricultural land of eastern Long Island for housing as the suburbs exploded in western Suffolk County and the 1972 Long Island Expressway extension to Riverhead made the area more accessible. A serious drop in potato prices devastated farmers' potato crops and forced many of them to sell their lands to developers.

As you read through this book, you will discover that Greenport is an ever-changing place. You will also notice that it is a feisty community that knows how to muster its resources. As the community finds its way in the 21st century, its full-time population has dwindled, and many houses, now lived in by part-time residents, are dark when you pass by them in the evenings. During the summer, however, and on many weekends during the off-season, the streets are jam-packed with tourists who arrive by cars, boat, trains, bikes, bus, motorcycles, and ferryboats to visit our vibrant seaside community and port. Throughout the summer season, tall ships from throughout the world visit us, and periodically, we host tall ship festivals as well as the annual East End Seaport's Maritime Festival. The streetscape remains ready to reveal the story of the community, as are the many small history museums this mile square village sports: the Margaret E. Ireland House of the Stirling Historical Society, the Greenport Jail, the East End Seaport Museum, the Railroad Museum of Long Island, a working blacksmith shop, and the camera obscura in Mitchell's Park. Come visit us and check them out.

One

A TRANSPORTATION HUB

With the arrival of the Long Island Rail Road (LIRR) in 1844, Greenport was transformed from a small boatbuilding, fishing, and trading port to a busy transportation hub. Prior to the railroad, the only means of transportation was the King's Highway (now County Road 48) or sailboat. The LIRR was designed as a link in the route from New York City to Boston. Travelers would take the train from Brooklyn to Greenport, where they would transfer to a steamboat to Stonington, Connecticut, and from Stonington continue by train to Boston. The development of steamship lines plying Long Island Sound helped transform Greenport into a busy harbor. Steamships traveled from Greenport to other points on eastern Long Island, New York, Connecticut, and points up and down the East Coast. The bankruptcy of the LIRR with the completion of a railroad line from New York City to Boston through the hills of Connecticut did not end Greenport's reign as a travel destination, with vacationers using the LIRR and steamships to visit Greenport and surrounding hamlets. Hotels, boardinghouses, and eateries sprang up to accommodate travelers and vacationers.

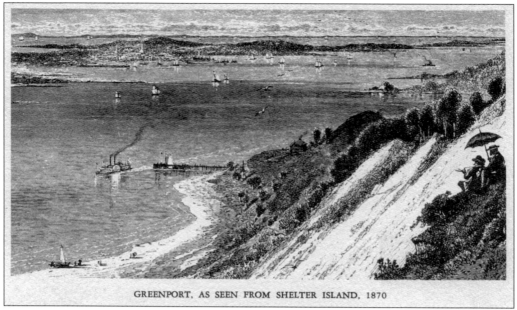

GREENPORT, AS SEEN FROM SHELTER ISLAND, 1870

Shelter Island, across Peconic Bay from Greenport, was an early and frequently travelled route. White Hill on Shelter Island was a popular spot for climbing and passive recreation. The steep sandy face of the hill, which was the highest point in the area, made for a challenging climb. Climbers defoliated the hill for many years until the activity was discouraged. The location of one of the landings for the ferry from Greenport to Shelter Island is center left in the postcard. (CDJ.)

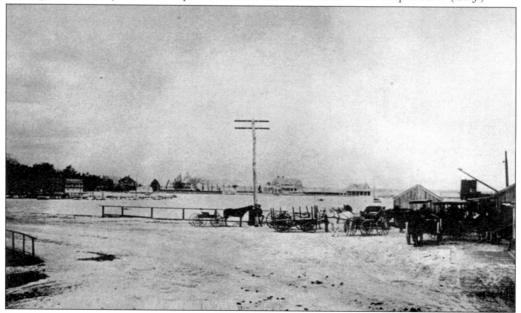

The original Shelter Island terminus of the North Ferry in Dering Harbor is pictured here. Although a handful of captains would take people across the bay, the first charter for a ferry was granted to Jonathan Preston in 1863. The business changed hands many times, and the ferryboats were modified with numerous modern improvements. (CDJ.)

Greenport and Shelter Island Ferry Company was incorporated, and it built the side-wheel, steam-powered ferryboat known as the *Menantic*. On board the *Menantic*, as it pulls into the Shelter Island terminus of the North Ferry, is a group of Civil War veterans on an outing. (SB.)

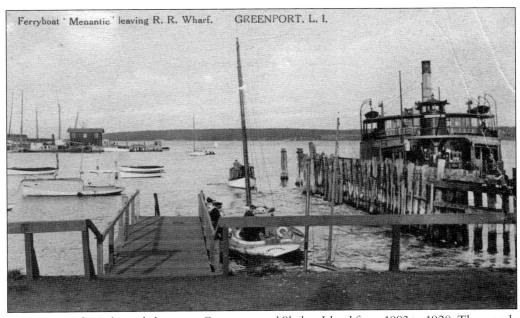

The *Menantic* ferried people between Greenport and Shelter Island from 1893 to 1920. The wood-hulled side-wheeler was 98 feet long and 45 feet wide at 203 tons. It was the first double-ended ferry. Passengers were charged 10¢, and the passage took one hour. (CDJ.)

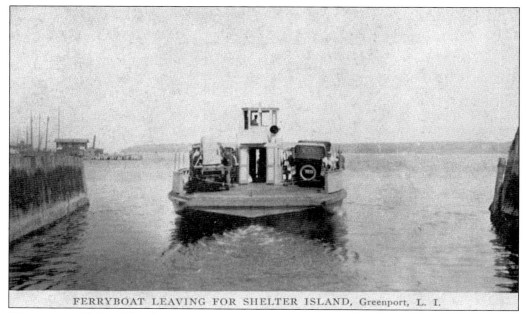

FERRYBOAT LEAVING FOR SHELTER ISLAND, Greenport, L. I.

The original Shelter Island Ferry terminus was at the south end of Main Street in Greenport, where vehicles queued along the west side of the street. The remnants of the ferry terminus can be seen in the new pavement the State of New York constructed on lower Main Street, while leaving the maintenance of upper Main Street to the village of Greenport. (CDJ.)

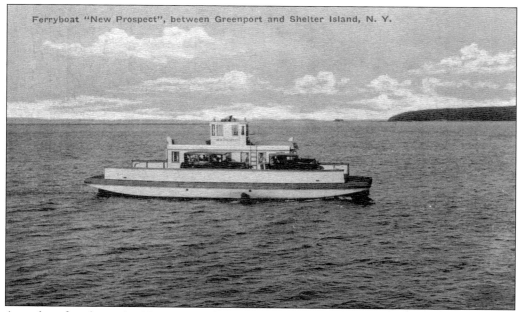

Ferryboat "New Prospect", between Greenport and Shelter Island, N. Y.

A modern ferryboat, the *New Prospect*, heads for Shelter Island from the Main Street Greenport ferry slip. (SB.)

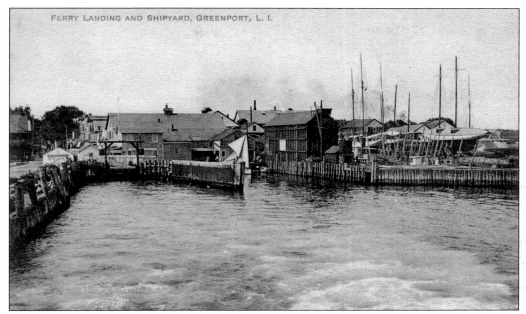

A ferry leaves the Main Street ferry slip at left, a ship's chandlery is at center, and the Greenport Basin & Construction Company shipyard is seen at right. The North Ferry alternated using the slip at the foot of Main Street with the ones at the end of Third Street (then known as Railroad Avenue). By the mid–1950s, traffic proved too much for Main Street, and the terminus was closed. All traffic moved to the Third Street terminus. (CDJ.)

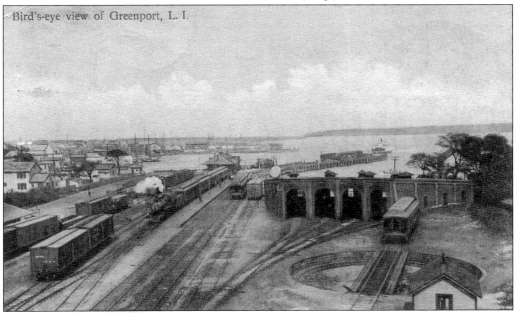

Bird's-eye view of Greenport, L. I.

This view of the Greenport terminus of the LIRR shows freight cars, passenger cars, a roundhouse, turntable, a ferryboat pulling in, and the railroad dock. The railroad dock has railcars stored on it and coal waiting to be loaded onto boats. The locomotive watering and coal facilities were located on the south side of the tracks, west of Fourth Street. (CDJ.)

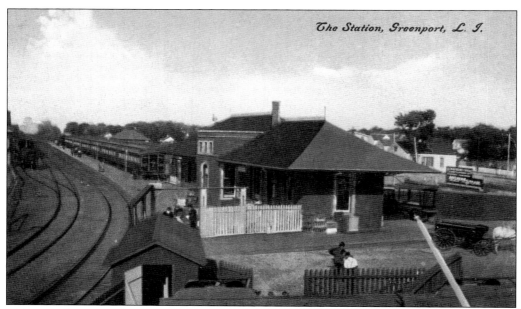

This early image of the railroad station was taken from the pilothouse of a ferry in the Third Street slip. (SB.)

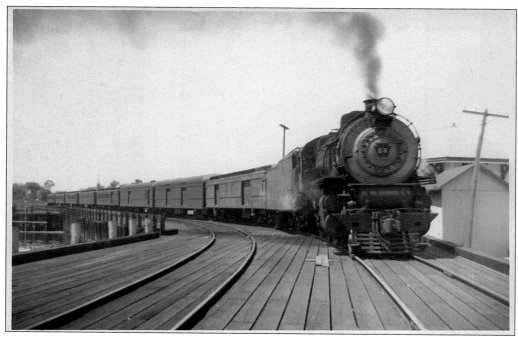

A LIRR steam locomotive pulls into the Greenport train terminal. The train has passenger, postal, and freight cars. The railroad dock allowed trains to pull out over the water where passengers could board waiting steamships. By the time this postcard was produced, the steamship connection to Stonington, Connecticut, was no more. (CDJ.)

Seen here is the Greenport railroad terminal during the days when station wagons, affectionately called woodies, were wooden-sided. (SB.)

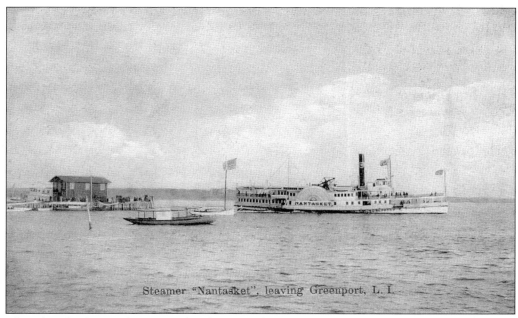

The side-wheel steamship *Nantasket*, shown underway in Greenport Harbor, was owned by the Boston and Nantasket Steamboat Company. At one time, it operated out of Pier 13 at the foot of Wall Street. The *Nantasket* was typical of the steamships that plied Long Island Sound in the 19th century. Note the walking beam that connected the steam engine to the side wheel. The walking beam was popular with excursion passengers, as they could see the engine working. (SB.)

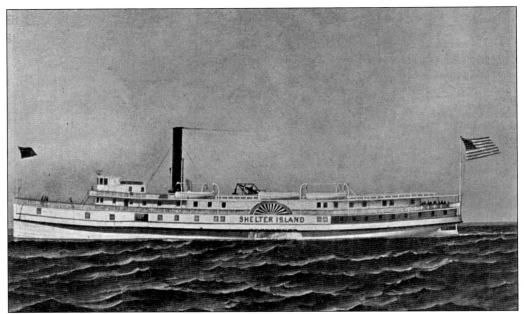

The Montauk Steamboat Company owned the steamship *Shelter Island*. Ships like this filled Greenport Harbor as they carried passengers between New York City, Greenport, Shelter Island, Orient, the South Fork, and Connecticut. Note the wisp of smoke coming out of the smokestack. Most postcards are touched up to remove the sooty smoke emulating from the boiler. (SB.)

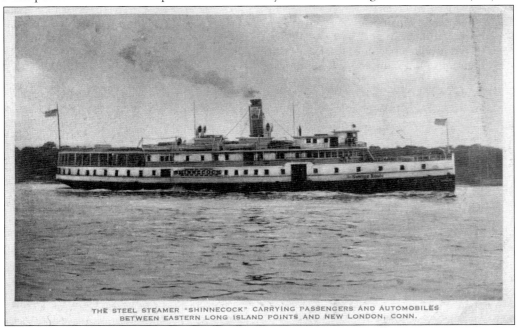

THE STEEL STEAMER "SHINNECOCK" CARRYING PASSENGERS AND AUTOMOBILES
BETWEEN EASTERN LONG ISLAND POINTS AND NEW LONDON, CONN.

The steamer *Shinnecock*, under command of Capt. George Rowland, made a record-breaking run from Miami to her home port of Greenport in four days and two hours. The *Shinnecock* was owned by the Montauk Steamboat Company and spent the winter of 1906–1907 plying the waters between Key West and Miami. (CDJ.)

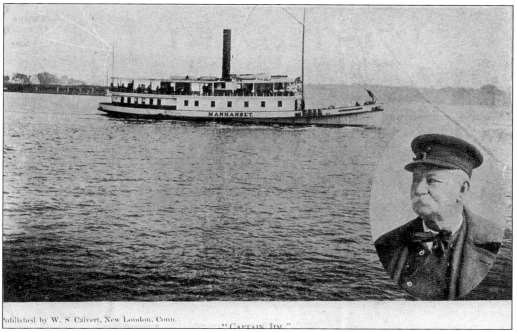

"CAPTAIN JIM"

The steamer *Manhanset* ran between New London and Greenport and surrounding points. In May 1910, the propeller fell off the steamer while running through Plum Gut off Orient Point. The oyster steamer *Larry Latham* towed the *Manhanset* back to the Greenport Basin & Construction Company yard for repairs, and the steamer *Wyandotte* was placed in service for the New London run. The steamboat *Montauk* was fired up for the *Wyandotte*'s usual run to New York. (RW.)

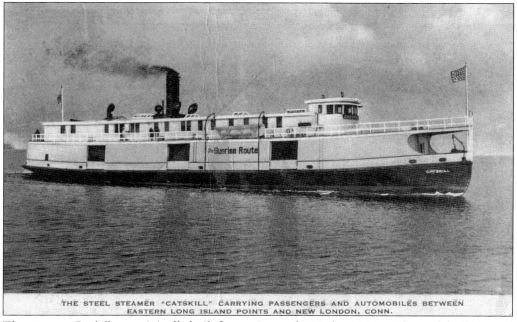

THE STEEL STEAMER "CATSKILL" CARRYING PASSENGERS AND AUTOMOBILES BETWEEN EASTERN LONG ISLAND POINTS AND NEW LONDON, CONN.

The steamer *Catskill* was originally built for service on the Hudson River. The steel-hulled vessel served on the route from Bridgeport to Port Jefferson until 1967. (SB.)

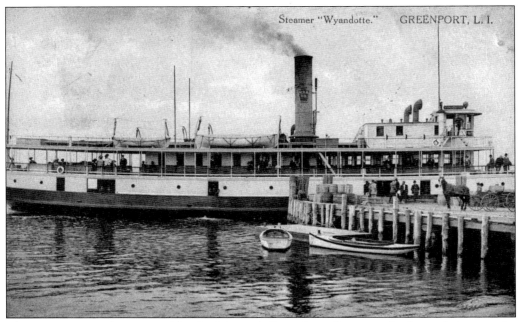

The steamer *Wyandotte*, owned by the Montauk Steamboat Company, is pictured above at the Main Street pier, also known as the Steamboat pier. The ship plied the waters between New London and Greenport and surrounding areas. (CDJ.)

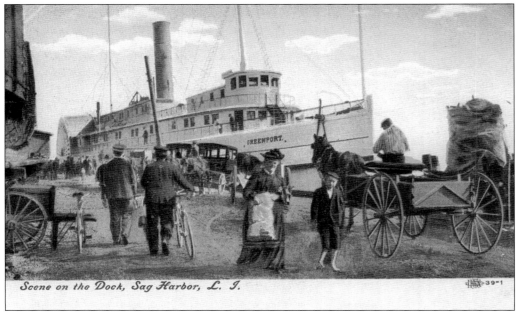

This Sag Harbor postcard depicts passengers debarking from the steamship *Greenport*, which arrived from Greenport. An excellent example of the early intermodal system that allowed water-bound islanders, visitors arriving at the Greenport Long Island Railroad station, and local people to travel between the north and south forks. (SB.)

Two

THEY PLIED THE WATERS

The earliest European settlers in Greenport followed in the path of the Poquatuck Indians and developed fishing as a part of Greenport's livelihood. One of the early fishing industries was the menhaden fishery with try pots placed on the shore to render the menhaden into oil and meal. The pots had to be located in sparsely populated areas because of objection to the odors and fear of fire. Bottom fishing with trawls, spearing sailfish, scalloping, oystering, and clamming and the menhaden fishery, along with party boats, were just some of the methods used to take the sea's bounty. Overfishing, habitat destruction, and pollution slowly shrunk the fishing industries. SPAT is the name of the Cornell Cooperative Extensions program that encourages community members to become stewards of their environment and to restore shellfish to the bays. The name is derived from the word *spat*, the tiniest form of shellfish that has settled into a place where it will live out its life. This program has encouraged a resurgence of oystering; as new timers rediscover the ways of old, over 400 people have participated in this community program that just keeps on growing.

JAMES M. MONSELL,

——PLANTER AND SHIPPER OF——

Oysters and Clams,

Greenport, Suffolk Co., N. Y.

FOR..

..

..

PER..

THIS PACKAGE RETURNABLE.

Oystering was a big industry in Greenport until the 1960s. The Greenport waterfront supported several large oyster operations. The 1938 hurricane initiated the decline of the industry. The demise was accelerated in the 1950s with the diseases Dermo and MSX, which were caused by protozoa. It is believed that Asian oysters introduced the diseases. (CDJ.)

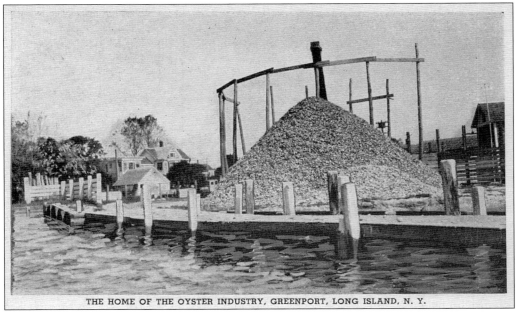

THE HOME OF THE OYSTER INDUSTRY, GREENPORT, LONG ISLAND, N. Y.

Oyster shells piled high were not a waste product of the industry but transported to New Haven Harbor, where the brackish water was ideal for spawning. After the oyster spat set, the shells were dredged up and transported to Greenport, where the saltier water was better for fattening the oysters. (FML.)

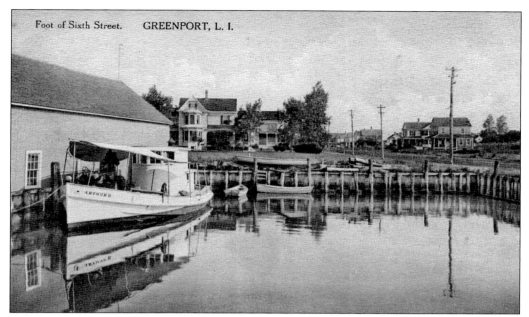

Foot of Sixth Street. GREENPORT, L. I.

The boat basin is at the end of Sixth Street with the oyster boat *Arthur B* tied up to the basin. Postcards of oystering operations are scarce; after all, the sites that were associated with foul odor were to be avoided. The odor was offensive to some; others said, "It smells like money." (SB.)

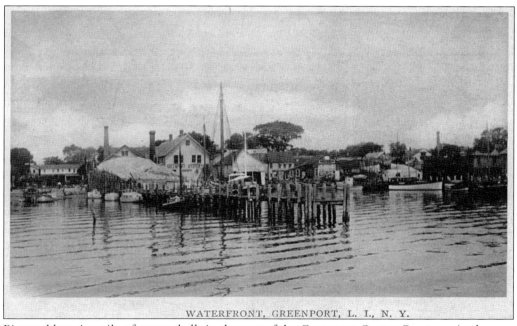

WATERFRONT, GREENPORT, L. I., N. Y.

Pictured here is a pile of oyster shells in the rear of the Greenport Oyster Company in the area of downtown Greenport Harbor. Another pile of oyster shells can be seen to the left of the postcard. Surplus shells were a popular covering for driveways and trails. (JM.)

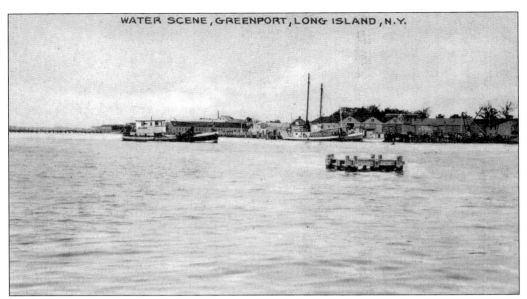

An oyster boat heads into its mooring at the Shelter Island Oyster Company in Sterling Creek. Sweets Shipyard, at the end of Central Avenue, is in the background. (CDJ.)

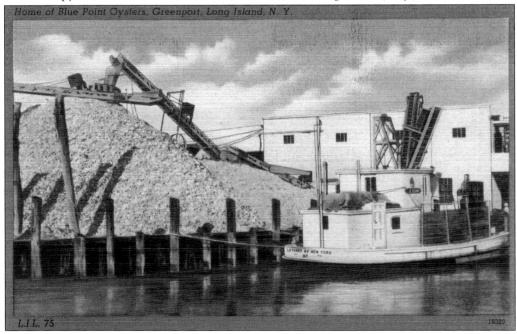

Home of Blue Point Oysters, Greenport, Long Island, N. Y.

L.I.L. 75

The Shelter Island Oyster Company was located at the foot of Sterling Avenue. The caption on the postcard is erroneous in calling the Peconic Bay oysters as Blue Point oysters; the inferior Blue Point oysters came from the Great South Bay. The Plock family, owners of this Shelter Island Oyster Company, presented a display on the growth of oysters to the Stirling Historical Society. After the company closed, it became a fish-processing plant, along with the R.J. Cooper plant on Carpenter's Street. These plants provided entry-level jobs to many African Americans who moved here from down south looking for work. (FML.)

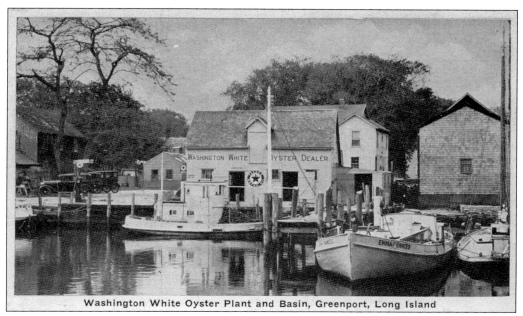

Washington White Oyster Plant and Basin, Greenport, Long Island

Washington White opened his oyster plant at the foot of Ludlum Place on Rackett's Cove in 1926 and ran the company until 1931, when Robert Utz Sr. bought the business. White then purchased the building on the south end of Main Street that was occupied by the Fiske Plumbing Store on the south side and Rupert Arnold's Fish Market on the north side. His newly minted business, Washington White and Son Hardware Store, is still family owned and operated by Stuart Koglehaus since White's son Bob and daughter-in-law Lillian retired in 1990. (RW.)

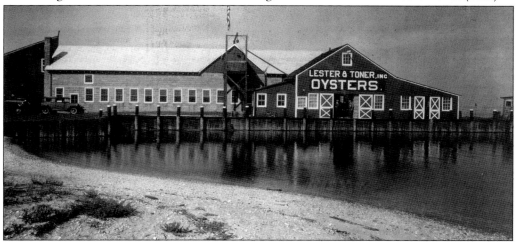

The Lester & Toner Oyster Company was located at Fanning Point at the end of Fifth Street. Lester & Toner was one of the largest oyster companies located in Greenport. Oysters were shucked and shipped in tin cans, or they were shipped in the shell in wood barrels that were placed in reefer cars on the Long Island Rail Road. The reefer cars were chilled with ice that was produced at the ice plant located adjacent to the west side of the Lipman Block. The Lester & Toner shop had a brief service as a disco in the 1970s before it was torn down and replaced with the Oyster Point condominiums. Part of the shop was moved to ELIH by barge where it is an outbuilding. (DK.)

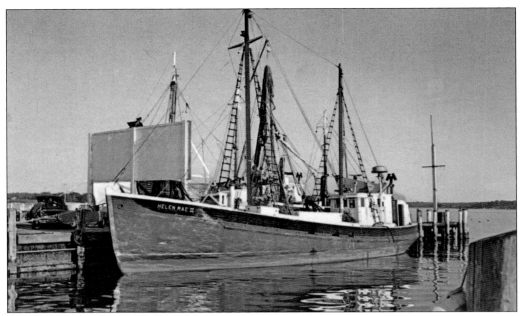

The fishing boat *Helen Mae II* is tied up to Claudio's dock. Trawlers like this were once a common site in Greenport Harbor. Overfishing of bottom fish, as well as species migration to other waters, again decimated a fish resource, and the fishing fleet and its support services, such as fuel and ice, slowly disappeared. The fishing boats out of Greenport can now be counted on one hand. (SM.)

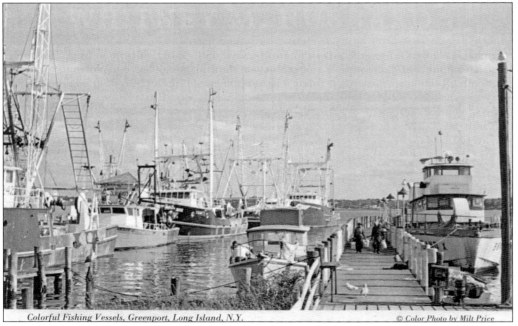

Colorful Fishing Vessels, Greenport, Long Island, N.Y. © *Color Photo by Milt Price*

The Rose boats, which migrated from North Carolina, tied up at Claudio's dock in the 1970s. Some mark the end of large-scale commercial fishing out of Greenport by the disappearance of the Rose boats from the scene. (MPC.)

Three

WALKING THE STREETS

The progression of Greenport's houses and streets over the years is an interesting subject. The streets improved with graded dirt roads; water mains; sidewalks and curbs; telegraph, electric, and telephone lines; and finally, paving. The houses regressed with the removal of ornate embellishments, porches and superstructures, and stables and barns. Whereas most of the housing stock is vintage and comprises a sizable historical district within the village, only a portion of the downtown district, lower Main Street, qualifies for the district because so many of the original stores have either been lost in a fire or razed in the course of progress.

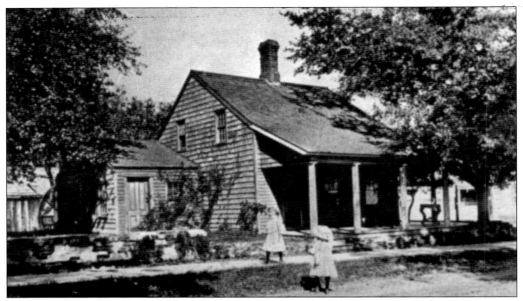

This iconic picture of a home in Greenport is notable as the oldest house in Greenport, and it still stands today. Near the heart of the shopping district, the understated house is a testament to the community's strength and staying power. (CDJ.)

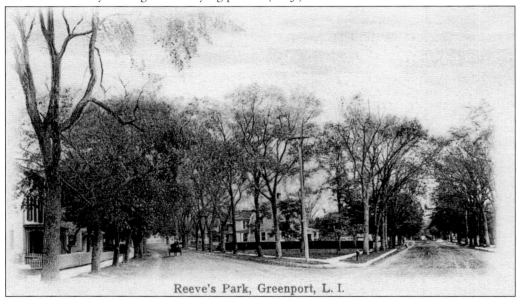

Reeve's Park, Greenport, L. I.

Reeve's Park, before the monuments, before paving, and after electricity, is now referred to as Steamboat Corner. It did not take on the name because steamboats were docked nearby, but because it came to a point like the bow of a steamboat. Now the park features both a World War I and a World War II monument as well as a combined Korean and Vietnam monument dedicated to all the men and woman of the community who defended the country in those wars. In 1987, the park was dedicated as Veteran's Memorial Park. The Village of Greenport Tree Committee is planting new trees to restore the area to its former leafy beauty, a focal point as one approaches the village where the north end of First Street merges with Main Street. (CDJ.)

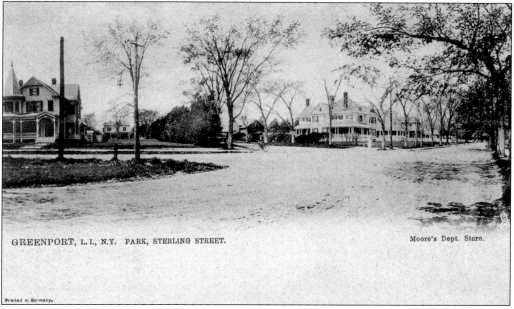

GREENPORT, L. I., N.Y. PARK, STERLING STREET. Moore's Dept. Store.

Printed in Germany.

In this image of the intersection of Main, First, and Webb Streets, note all of the elm trees in front of the house on the north side of Webb Street. The streets of Greenport had many stately elm trees. Many were blown down in the hurricane of 1938. Those that withstood the hurricane did not survive the Dutch elm disease starting in the 1950s. The area north of Webb Street was once called Murray Hill. (CDJ.)

This house on Main Street, across from Reeve's Park, is now part of the Townsend Manor Inn. Note the horse and buggy in the driveway and the concrete sidewalks. The roads were still dirt at the time of this postcard. (SB.)

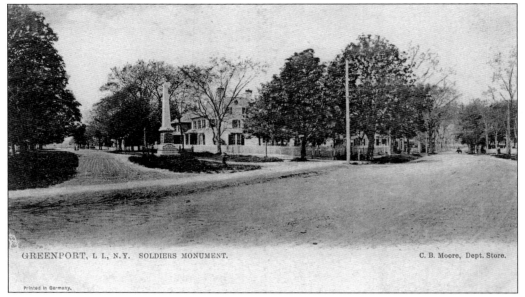

GREENPORT, L. I., N.Y. SOLDIERS MONUMENT. C. B. Moore, Dept. Store.

Printed in Germany.

Electricity, water, and sidewalks are in place on this block south of Murray Hill at Main and Broad Streets, but there are no paved roads. (CDJ.)

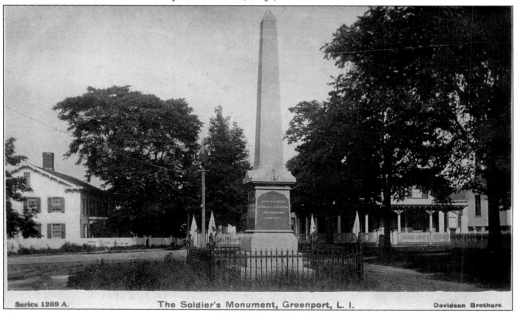

Series 1269 A. The Soldier's Monument, Greenport, L. I. Davidson Brothers

The monument to the soldiers from Greenport that served in the Civil War—Company H, 127th Regiment of the New York Infantry Volunteers—is seen above. Company H was recruited at the Methodist church and enlisted on August 21, 1862, for a three-year term. The 127th Regiment was based on Staten Island. The regiment was assigned to guard duty around Washington, DC, until April 1863. They were moved to Suffolk and took part in the Siege of Suffolk. The regiment also took part in the pursuit of the rebel army after Gettysburg, operations against Charleston, the assault on James Island, the Battle of Looney Hill, and the demolition of the Charleston & Savannah Railroad. (CDJ.)

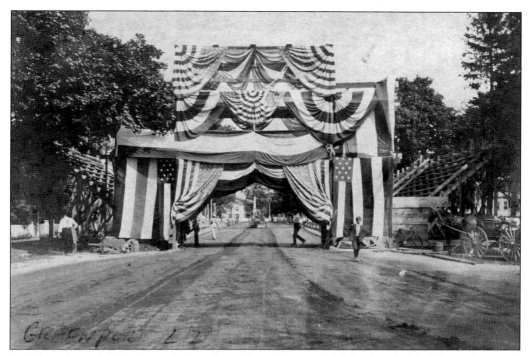

Seen here is a celebratory patriotic arch on Broad Street with bleachers behind the arch as well as a grader smoothing the surface of the dirt road. The arch may have been constructed for the dedication of the Civil War monument visible in the background. (SB.)

Dr. E.E. Skinner's house on Main Street was originally built in Orient by Noah Beebe. Dr. Skinner bought the house from Lewis Edwards and moved it to Greenport, where it stands to this day. This postcard shows the first renovation. The second renovation of the structure was in 1929 by Boss D. Stanley Corwin. (DC.)

This house on Broad Street still stands today, sans the widow's walk and the shutters. (SB.)

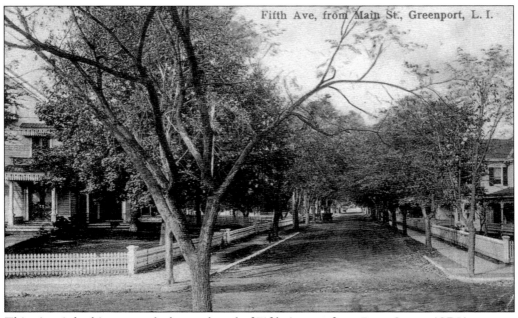

Fifth Ave, from Main St., Greenport, L. I.

This view is looking towards the south end of Fifth Avenue from Front Street. (CDJ.)

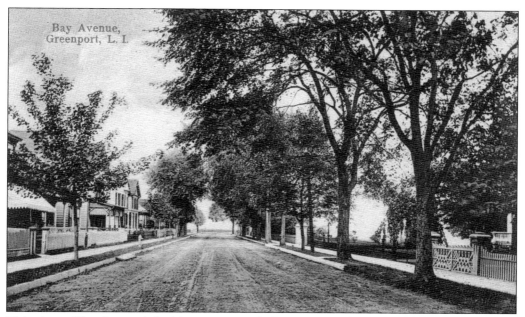

This view of Bay Avenue is looking east towards Greenport Harbor. The Reeve Estate is on the right of this postcard. (CDJ.)

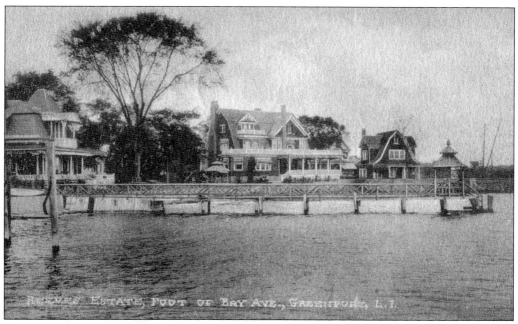

The Reeve Estate, located on the water at Bay Avenue, later became the property of Harry and Pauline Mitchell. The boathouse on the right was moved to Carpenter Street opposite Sterling Avenue in the 1970s. (RW.)

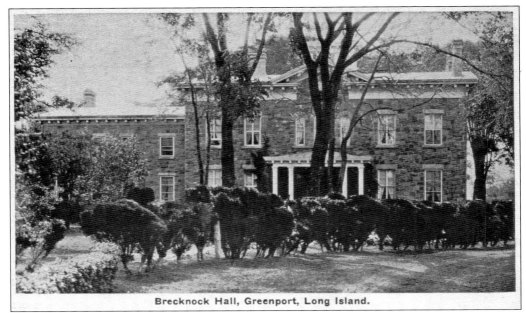

Brecknock Hall, Greenport, Long Island.

Brecknock Hall was constructed for David Floyd, the grandson of William Floyd, a signer of the US Constitution. Floyd made enough money from one whaling voyage to build this grand home. The stones for the structure were collected and hued on-site by Scottish stoneworkers. (CDJ.)

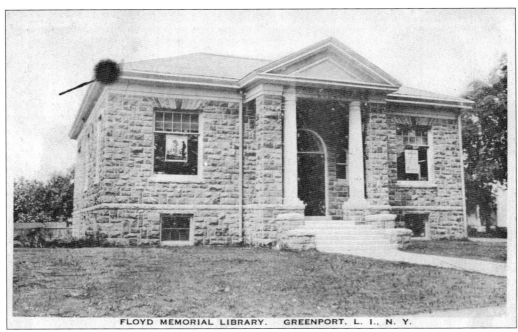

FLOYD MEMORIAL LIBRARY. GREENPORT, L. I., N. Y.

The Floyd Memorial Library was built in 1917. The library was a gift to the community from Grace Floyd in memory of her father, David Floyd. It was constructed on the former First Street site of the Congregational church, which burned down. The stonework is rock hued from the glacial erratic rocks that litter the shoreline of Long Island Sound. (RW.)

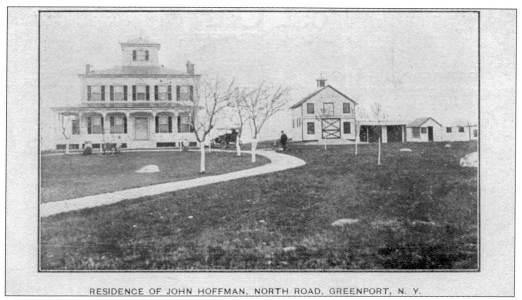

RESIDENCE OF JOHN HOFFMAN, NORTH ROAD, GREENPORT, N. Y.

The Hoffman Estate on the North Road later became a well site for the Village of Greenport Utility Department. In 1998, the Suffolk County Water Authority purchased the Greenport water system. (CDJ.)

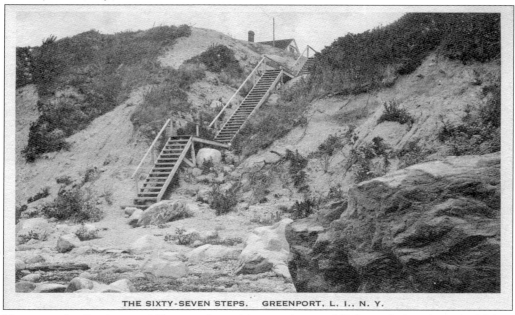

THE SIXTY-SEVEN STEPS. GREENPORT, L. I., N. Y.

No postcard collection would be complete without a picture of 67 Steps. Swimming, picnicking, viewing the sun drop into the water, and fishing at 67 Steps, the nearest Long Island Sound beach in Greenport, have long been favorite activities at this spot—at least for those willing to climb down the many steps that vary from time to time. To the left, at the road end top of the bluff, is a lovely park that overlooks the area of the scene below. The park was dedicated to a beloved Greenport High School English teacher, Dr. Dennis Claire, who encouraged, challenged, and inspired all he encountered. (SB.)

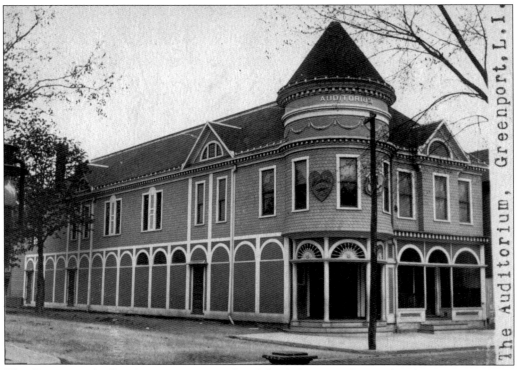

The Greenport Auditorium was conceived and funded in 1894 by Sarah Adams to "uplift the moral tone of the community" and featured early movies, lectures, and other entertainment of the times. The building, now known as Golden's Furniture Store, owned by the Aurichio family, still stands on the corner of Central Avenue and Main Street with the original stage and all the works of a theater still intact. It calls out to raise the curtain once again. (CDJ.)

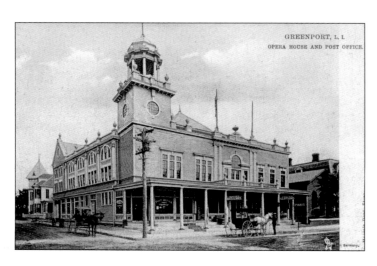

Stirling Hall, a popular meeting place on Bay and Main Streets in the village, was replaced after a fire by the Greenport Opera House, which also included a post office. This ornate wooden structure, which later suffered a fire itself, continued to provide cultural offerings until it was torn down and eventually became a parking lot for the future People's National Bank. (CDJ.)

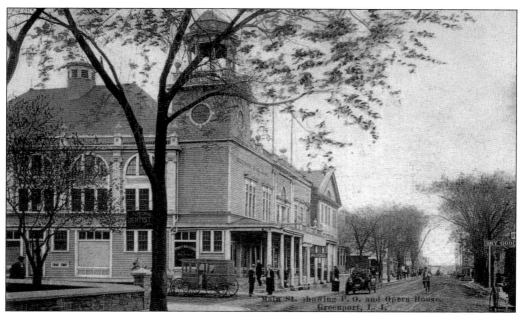

Looking south towards Main Street Wharf, this side view of the Greenport Opera House shows the entrance to the Greenport Post Office. (CDJ.)

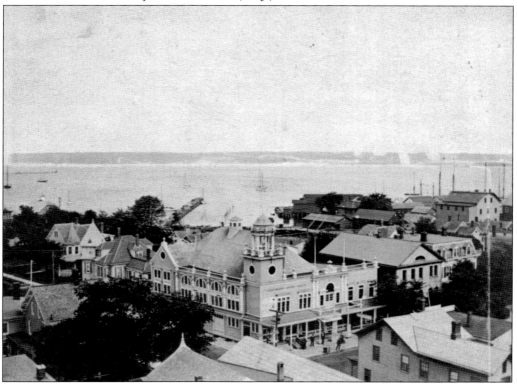

This fine aerial shot of the east side of Greenport Village's commercial district features the Greenport Opera House as the focal point and the shores of Shelter Island in the distance. (SB.)

This charming view of the horse-and-buggy era in Greenport reveals Main Street's well-used dirt road and a sign advertising the public library on the front deck of the Greenport Opera House. At left in the photograph is Arnott's Drug Store. In the 1970s, it was purchased by May and Phil Watson and converted to an attractive shopping mall with accessory apartments known as Stirling Square. (RW.)

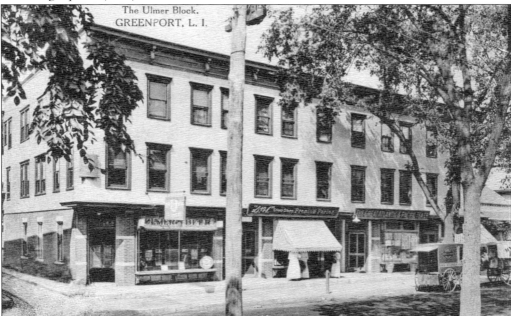

This c. 1910 large, brick concrete structure was the last home of the U Saloon, which served Uhlmer's Beer, and features two top stories of apartments and a ground floor of stores. The Lipman Brother's men's store was among the first commercial tenants and, at a later date, purchased the property. Once called the Uhlmer's Block, the name changed to the Lipman Block. The building, near the northern end of Greenport's commercial district, still functions as originally intended and includes art galleries and clothing stores on the ground floor. (CDJ.)

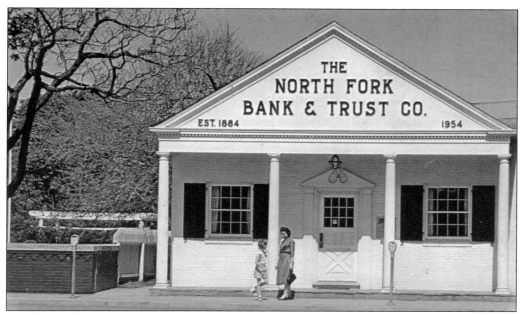

The North Fork Bank on Main Street was purchased from the First National Bank in 1954. The building was torn down in 1976 along with the neighboring 1831 Klipp House. An asphalt parking lot was constructed on Main Street along with a new brick and clapboard bank building. The demolition of the Klipp House raised public conscience about the preservation of historic buildings and paved the way for the eventual creation of the Village of Greenport's Historic Preservation Law and Commission. The North Fork Bank was later bought by Capitol One Bancorp. (CDJ.)

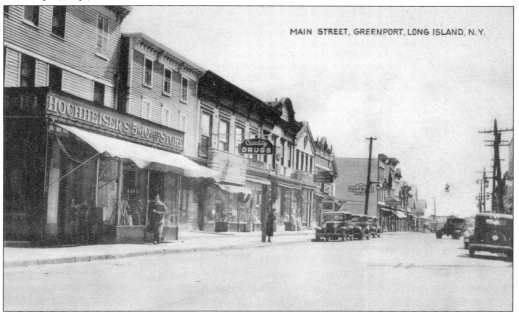

This is a view of the east side of Main Street heading towards Main Street Wharf during the early 20th century. Hochheiser's five-and-dime store is the first shop on the left. (CDJ.)

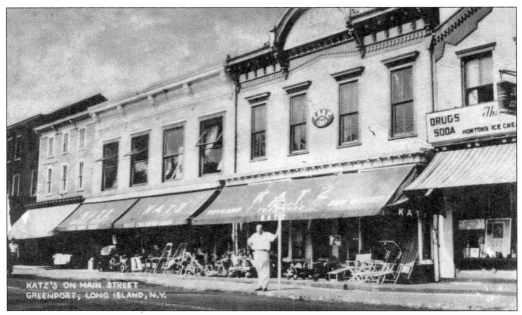

The Katz family had several stores in Greenport, including these three on the east side of Main Street between East Front Street and Bay Avenue. On the far left was Schaumberg's store. The building on the right was Corwin's Drug Store, later Kramer's Drug Store and now Bruce and Son's Cheese Emporium and Café. The large Katz store to the left now houses Jet's Dream (owned and run by a granddaughter of Louis B. Jaeger, whose department store was an important part of the business district for many years), the Shirt Shack, and DeLatte Café. (CDJ.)

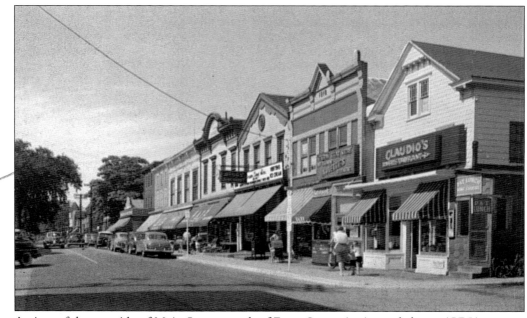

A view of the east side of Main Street, north of Front Street, is pictured above. (CDJ.)

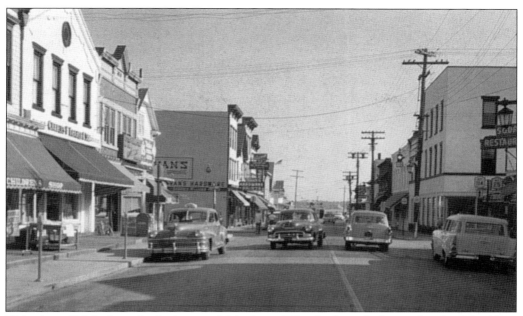

This view of Main Street looks down to Main Street Wharf, where the large white brick building on the right housed the William J. Mills Sail Making Company, which provided sails and many other canvas items from this site for many years. The ground floor consisted of stores, and the two upper floors held the offices and the sail loft. Needing more space, the company sold the property, which now offers apartments on the top two floors. The company built a modern plant with a showroom on west Front Street. (RW.)

The disastrous 1938 hurricane left the downtown area flooded and caused the village to lose many of its old trees. This view of Main Street Wharf illustrates the terrible story of that day. (SB.)

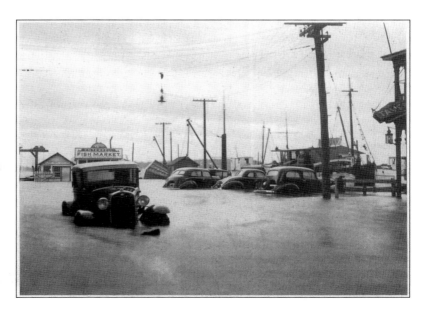

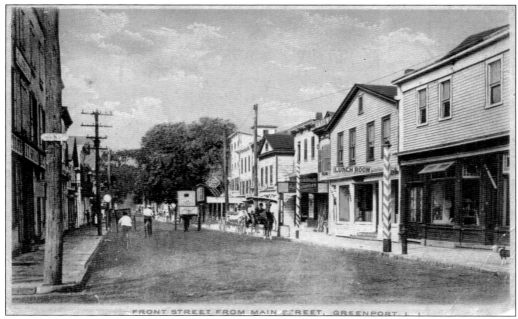

Samuel Levine established a store in 1928 and named it Variety Store-5¢-10-and Up. As other properties were added to the business, the name was changed to the Arcade Department Store. His son Arthur joined the business, and later his granddaughter Linda did as well. The store, whose slogan was "You can always find it in the Arcade," was sold out of the family in 1990 and has had three subsequent owners. This view looking west on Front Street is typical of the era, with bicyclists easily sharing the road with automobiles. (CDJ.)

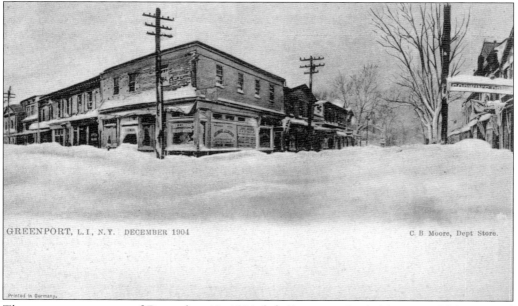

The severe snowstorm of December 15, 1904, left Greenport buried in snow. This postcard shows the stores and the roads on the northwest corner of Front and Main Streets mounded with great drifts of snow. (RW.)

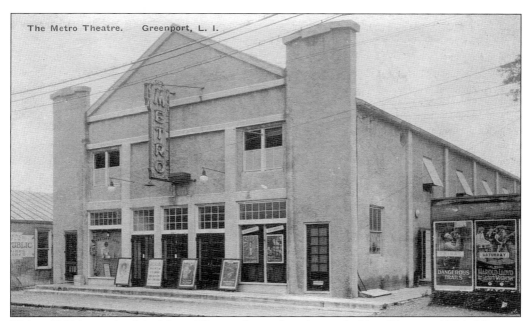

This c. 1920 image is of the Metro Theatre, located on the south side of Front and Third Streets, which featured the early silent films. The large billboard on the right advertises the upcoming films *Dangerous Trails* and *An Eastern Westerner,* starring Harold Lloyd. (SB.)

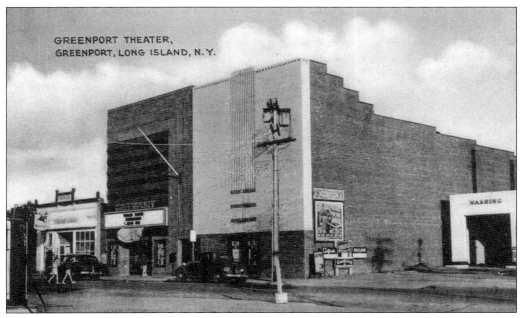

The large, modern Greenport Theater is flanked by garages on the left and the right. The present structure replaced the Metro after the Metro was blown down in the 1938 hurricane. On the afternoon of the 1938 hurricane, gas station attendant Tony Fiore noticed the Metro was about to collapse and ran across the street to alert the theater staff, who evacuated the moviegoers. The Metro was totally demolished, and the present theater took its place the following year. (CDJ.)

PUBLIC PARK, GREENPORT, LONG ISLAND, N.Y.

The visitors to the fine hotels once located on Third Street—the Wyandank, the Sterlington, and the Peconic House—were fortunate to have Prentiss Park, a peaceful waterfront spot, to relax in, breathe in the fresh salty air, and enjoy the view of Shelter Island across the bay. Greenport's recently added Harbor Walk, to the left where the Greenport Oyster Company once operated, now ends in this area, and it adjoins the North Ferry Service to Shelter Island on the right. (CDJ.)

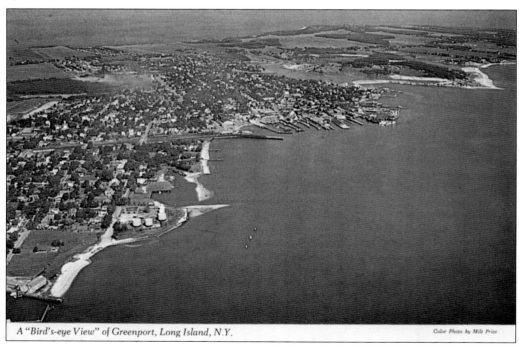

A "Bird's-eye View" of Greenport, Long Island, N.Y.

Color Photo by Milt Price

This 1920s aerial view of the working area of the Greenport waterfront shows the area where the bulk fuel storage terminal was installed at the end of Fourth Street, in the lower left third of the image. The tanks were called "Jake's Tanks" after Jake Tyler, who managed the docking services at Mitchell's Marina and lived nearby. The property was cleared in the 1990s. In 2013, Exxon Mobil donated the land; it was deeded to the Peconic Land Trust in a partnership with the Village of Greenport and the Town of Southold and will be left as is for passive recreation. Back in 1925, the chamber of commerce tried to purchase the property for a community bathing beach, but the proposition was refused, and Standard Oil became the owner. The price back then was $20,000; today, it is worth $1.4 million. (MPC.)

Four

LEISURE TIME

Greenporters have always been known to work hard, and they have also been known to have a good time, whether outside swimming, fishing, or boating in the surrounding waters; skating on Silver Lake or the Stirling Cemetery Pond; or hiking the Moore's Woods nature trail. The community offered many activities, including the Greenport Firemen's Washington Day Parade and tournaments, dances and roller-skating at the American Legion Hall, bowling and playing pool, and a myriad of sports activities. The polo grounds at Moore's Lane have always been a center for Little League and adult baseball games, craft fairs, and the visiting circus and carnivals In 1998, a skate park for in-line roller skates, skate boards, and BMX bikes was added to the grounds. Local school, churches, and theaters also provided sports and cultural activities. One could tire from all the fun offered in Greenport.

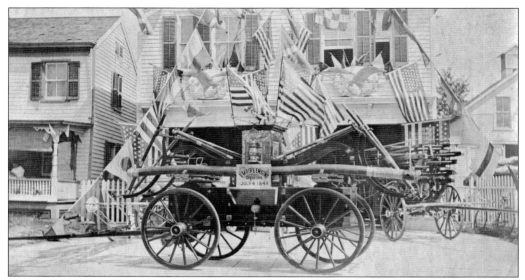

The Empire Company Engine is all decked out for a parade in 1849. The company no longer exists, but the hand pumper engine is on display at Fire Station No. 1 on Third Street in Greenport. (RW.)

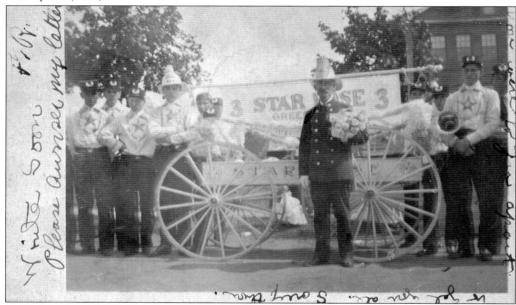

The Star Hose Company was organized in 1898 and joined the of the Greenport Fire Department in 1903. The annual Greenport Firemen's Washington's Day Parade featured a dry hose race where the contestants ran down a track carrying a length of hose. At the hydrant end of the course, one person had the job to attach the hose to the hydrant, then wait to open the hydrant at exactly the right time, timing it so that as the last competitor, who was a the nozzle end of the hose, reached the point where the hose was fully extended down the track, the water was just coming to the nozzle tip, at which point the nozzle man aimed the water at a flip-up target positioned a the end of the track. The Star Hose Company excelled at the dry hose race. They set a record of 20 seconds in the early 1900s that, as of 1988, had never been broken. (CDJ.)

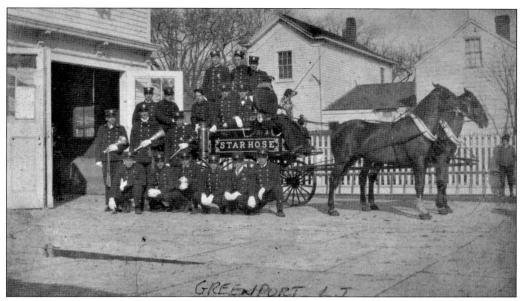

The Star Hose Company assembles for a parade at its South Street station, which first housed the Village of Greenport's electric generator. (RW.)

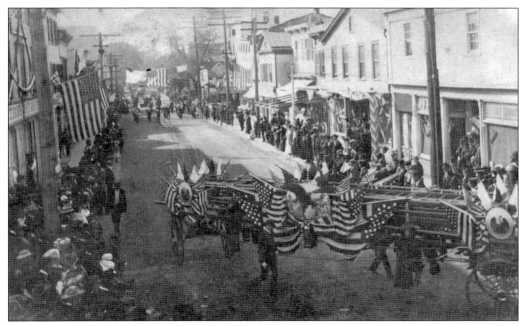

A Greenport Firemen's Washington Day Parade marches east down Front Street, ready to turn north on Main Street. (SB.)

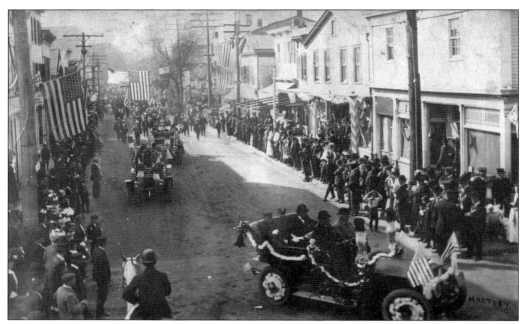

A car full of dignitaries leads a festive parade as it turns the corner at Front and Main Streets. (RW.)

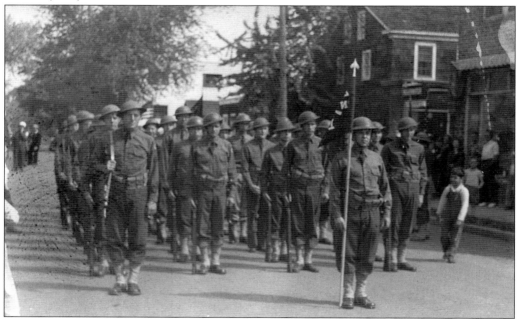

A group of World War I vets from the Burton Potter Post, stand at attention. Greenport's Burton Potter American Legion Post was founded in 1919. Greenport has always exhibited robust patriotism. During times of war, local men and women enlisted and served their country in the armed services. On the home front, the Civilian Defense efforts were very active. In the main hallway of the Greenport School, photographs of all the local service people line the halls with a brief history of their service noted. (CDJ.)

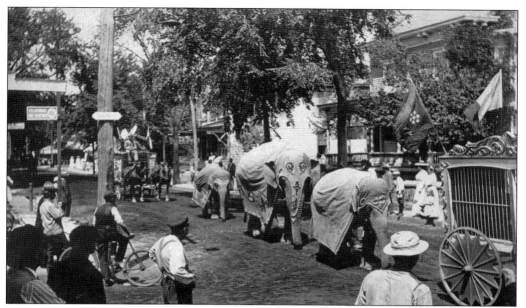

The village turns out to watch the circus parade as it marches down Main Street toward the downtown area. Elephants follow the cart holding the lions. (RW.)

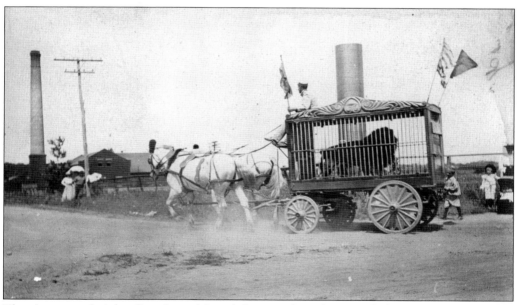

The circus parade is heading down Moore's Lane to the polo grounds from Front Street. Note the lion in the horse-drawn cage and the Greenport Light and Power Plant in the left background of this late-1920s image. In 1891, William H. Moore donated to the Village of Greenport the north/south road that ran through his property as well as the westerly adjoining polo grounds and Moore's Woods. (RW.)

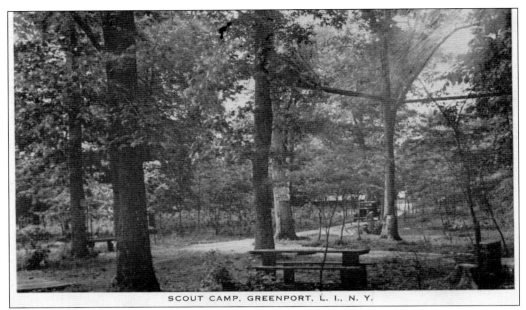

SCOUT CAMP, GREENPORT, L. I., N. Y.

When the Clarke house property was sold to the village in 1935, a section of the old inn that was used as a laundry was moved to the municipal grove in Moore's Woods on Moore's Lane. The building was remodeled and used as a Boy Scout camp house into the early 1970s, when it fell into disrepair. Across the road is the municipality-owned McCann's Trailer Park, which was given to the Village of Greenport by Herbert J. McCann to be used as a campground. (CDJ.)

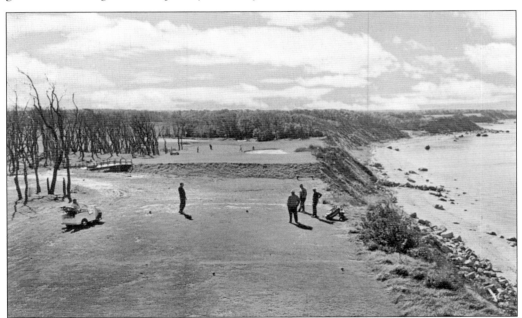

Island's End Golf Course opened on May 27, 1961. Conceived and built by Sheldon "Joe" Sage on the former farm of Eddie and Viola Prince, the 18-hole course has a spectacular view off the bluff at the 16th hole of the Long Island Sound, offering a peek of the Connecticut shore in the distance. The clubhouse was constructed using the barn from the Prince farm. (JM.)

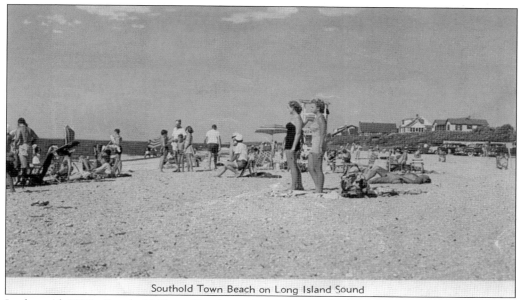

Southold Town Beach on Long Island Sound

In the mid–1930s, Southold Town Beach was improved as a bathing beach, and people flocked to swim in the crisp water and sun on the pebbly Long Island Sound beach, which also offered lifeguard protection. Swimming lessons and lifeguard training was offered to area children on summer mornings in July. (CDM.)

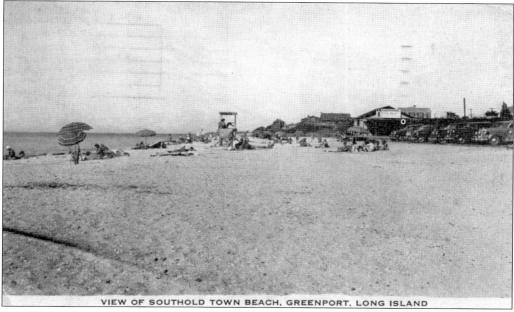

VIEW OF SOUTHOLD TOWN BEACH, GREENPORT, LONG ISLAND

In 1938, Jack Levine was offered the opportunity to open a concession stand on Southold Town Beach. Located on the east end of the beach, with Inlet Point in the background, Jack's Shack was an instant success. Levine bought Merkel's Hot Dogs and fresh ground beef from Kaplan's Market in Greenport; added beach chairs, lockers, and umbrella rentals; and lobbied to have a lifeguard, a float, and swim lines installed. From Riverhead to Orient Point, Jack's Shack, with its good food, jukebox, and casual atmosphere, was the place to be in the summer. (JM.)

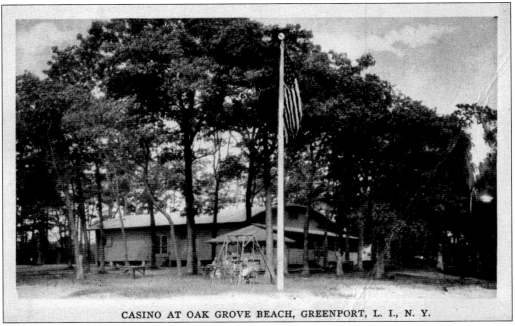

CASINO AT OAK GROVE BEACH, GREENPORT, L. I., N. Y.

In 1927, Oak Grove Beach was finally open to the public. Located on Peconic Bay between Sixth and Ninth Streets, this bay front property was an excellent place to spend summer days, but for 20 years, there were issues with the development of the property. The Casino, pictured above, featured dances with live bands and was a popular nightspot in Greenport. During World War II, as local men went off to war, attendance dwindled, and Oak Grove soon closed down. (RW.)

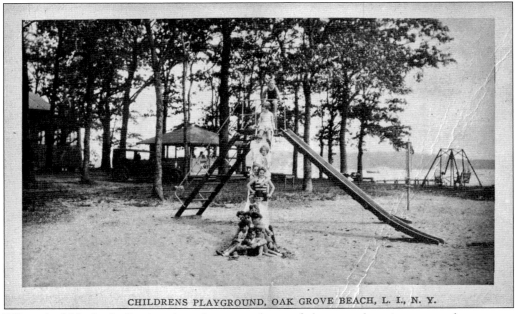

CHILDRENS PLAYGROUND, OAK GROVE BEACH, L. I., N. Y.

When the kids tired of swimming, there was plenty of playground equipment to play on near the bathing pavilion. Several astute local youngsters figured out a secret entryway to the Oak Grove Beach along one of the fences, and they avoided paying the daily entrance fee. (RW.)

Five

STIRLING CREEK

The entrance to Stirling Creek was the focus of the early community and trade, and the body of water was named Stirling in tribute to its first grantee from the British Crown, William Alexander, the Earl of Stirling. The west arm of the creek extended past Bridge Street as far Champlin Place. Ships ran up the west arm of the creek as far as Monsell Place, where they would be heeled over in the mud to smother the gribbles and ship worms that were the bane of all wooden ships. The heeling stone used to anchor lines to pull the ships over is still visible near the corner of Stirling Place and Monsell Place.

"Having a gay old time"

Harbor and Breakwater, Greenport, L. I.

The Greenport breakwater was constructed in 1893 at a cost of $46,000. Prior to construction of the breakwater, the point now called Young's Point was known as Joshua's Point. Storms moved the sand to the west, creating Sandy Beach. (SB.)

5201 STERLING BASIN, GREENPORT· L. I. ILLUSTRATED POST CARD CO., N. Y.

The west arm of Stirling Creek is viewed from the vicinity of Eastern Long Island Hospital. The Hemstead Pottery Works is in the center of the postcard. John Wesley Ketchum's Boatyard, built around 1885, had not been established at the time of this undated postcard. (SB.)

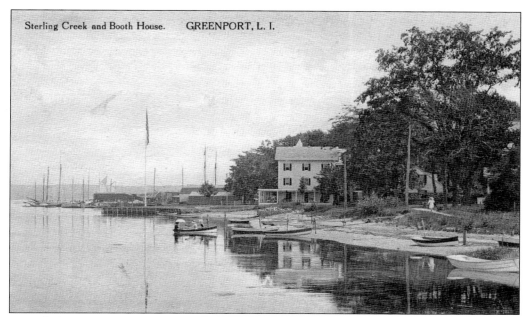

Sterling Creek and Booth House. GREENPORT, L. I.

A stroll down Sterling Street would yield this scene. The Booth House is in the center of the postcard. Sterling Street was the original King's Highway, which ended at the Booth House. When the breakwater was constructed, the entrance to Stirling Creek was dredged to improve it. The steam dredge struck an old, long-buried pier in front of the Booth House. The pier, said to extend 200 feet from shore, was the original Stirling pier, dating back to at least the mid-1700s. (CDJ.)

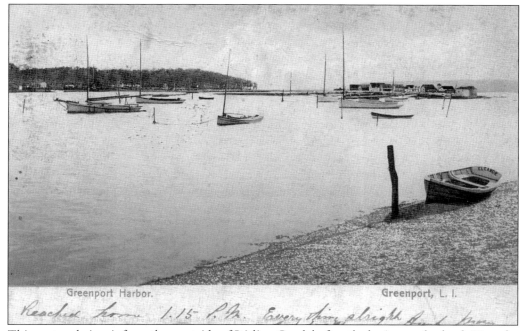

Greenport Harbor. Greenport, L. I.

This postcard view is from the west side of Stirling Creek before the basin was dredged. Note the stakes used to moor the sailboats. Sandy Beach is in the right background of the image. (RW.)

55

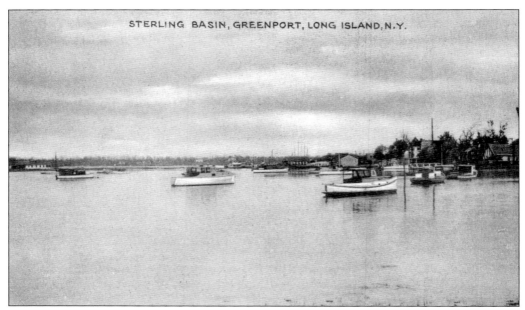

STERLING BASIN, GREENPORT, LONG ISLAND, N.Y.

Stirling Creek is seen here sometime later, with internal combustion engine-powered vessels moored with anchors. (CDJ.)

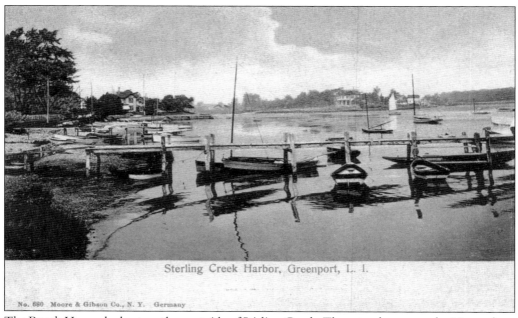

Sterling Creek Harbor, Greenport, L. I.

No. 680 Moore & Gibson Co., N. Y. Germany

The Booth House dock sat on the west side of Stirling Creek. The estate known as the Manor, later to become Eastern Long Island Hospital, is seen in the center right of the postcard. (CDJ.)

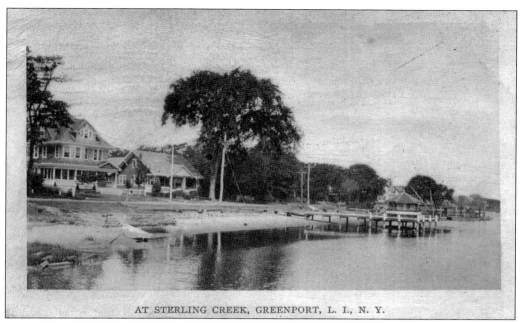

AT STERLING CREEK, GREENPORT, L. I., N. Y.

Pictured is the west side of Stirling Creek before the extensive bulkheading and docks were built. (SB.)

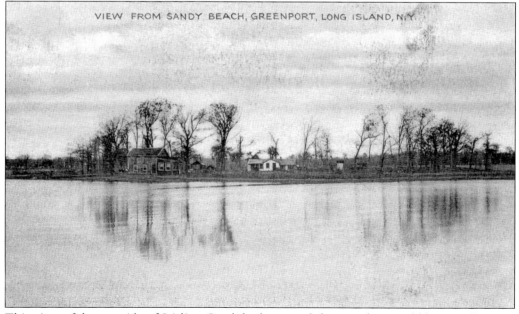

VIEW FROM SANDY BEACH, GREENPORT, LONG ISLAND, N.Y.

This view of the east side of Stirling Creek looks toward the area that would become Brewers Yacht Yard. (CDJ.)

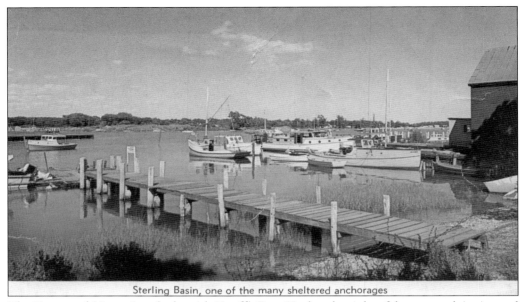

Sterling Basin, one of the many sheltered anchorages

The Townsend Manor Inn dock, with Hanff's Boat Yard to the right of the postcard, is pictured here. One local story claims that the captain of the dredge working on Stirling Basin was given a case of Scotch whiskey to dredge up to the end of the west arm of the creek, which allowed boats to get as far as the present Townsend Manor Marina. (CDJ.)

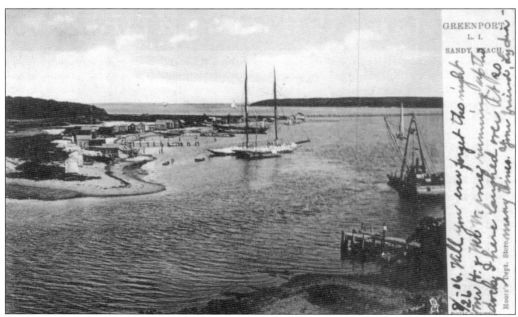

Above is the entrance to Stirling Creek viewed from atop the Booth House. Sandy Beach is on the left. A steel cable was strung across the entrance at one time, allowing dinghies to be hand hauled from Sandy Beach to the mainland. The entrance to Stirling Creek was much wider before stomes moved the sand along Sandy Beach to Sandy Point. (SB.)

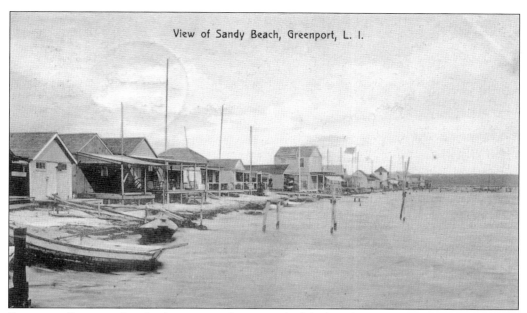

View of Sandy Beach, Greenport, L. I.

Former scallop-opening shacks were on the east end of the beach, and local people used to boat over to the beach to picnic on the west end. Eventually, around 1886, the locals turned the area into a summer resort, and the former scallop shacks were cleaned out and converted into bungalows. (CDJ.)

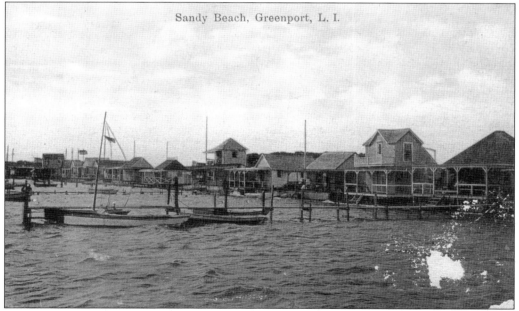

Sandy Beach, Greenport, L. I.

This is another view of Sandy Beach primed for summer fun on the spit of land, where with support from the Village of Greenport, the community, and a grant from the New York State Senate, a Monument for those Lost at Sea, whose Vermont granite columns embrace the north star, was designed and sculpted by Greenport artist Arden Scott and installed on the western spit of land with labor and equipment donated by local contractors. (CDJ.)

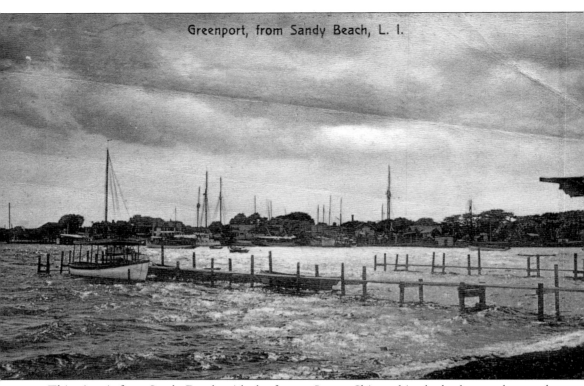

Greenport, from Sandy Beach, L. I.

This view is from Sandy Beach with the former Sweets Shipyard in the background, now the site of Sterling Cove Condominiums. (SB.)

Six

A Shipbuilding and Repair Center

Greenport had many shipyards and boatyards engaged in both new construction and repairs. Wooden boats require constant maintenance with the application of caulk and copper bottom paint every spring. The area around the Central Pier, located at the foot of Central Avenue, became what is remembered as Sweet's Shipyard. Yards were located from the mouth of Stirling Creek around Greenport Harbor as far as the present ferry terminal and in Widows Hole. The workers in the yards had a street named after them—Carpenter Street—where housing for the men engaged in the trade meant an easy walk to work.

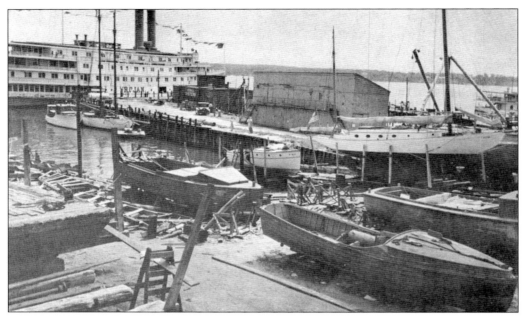

This view of the H. Fordham & Sons Shipyard looks east from the Central Pier and features the steamship *Greenport* moored at a pier. The *Greenport* was a walking beam side-wheeler, whose shallow draft let steamships like this moor in shoal water. (CDJ.)

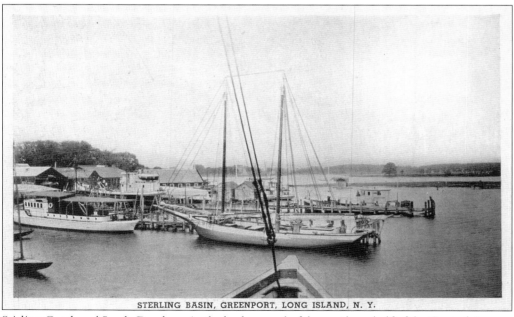

STERLING BASIN, GREENPORT, LONG ISLAND, N. Y.

Stirling Creek and Sandy Beach are in the background of the northern half of the Central Avenue shipyard later known as Sweets. (SB.)

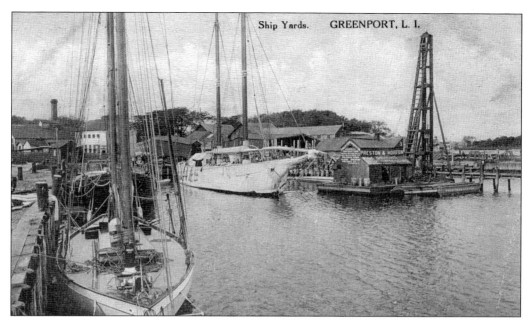

The Central Avenue shipyard, with the steam-powered barge owned by Preston & Horton, is to the right of this postcard. The barge is driving a pile for dock repairs. (CDJ.)

The Central Avenue Shipyard, with a schooner pulled up on one of the marine railways for repairs, is seen above. (SB.)

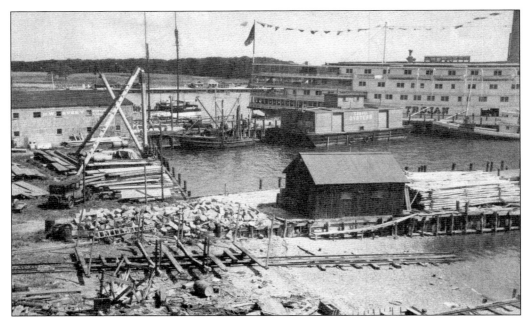

The H.W. Sweet shipyard is seen here with the *Trojan* moored at the Central Pier. Sandy Beach is in the background with the bulkhead but only a few shacks. Note the pile of ballast rocks in the middle left of the postcard. The foundations of most of the older houses in Greenport were built with ballast rocks like these. (SB.)

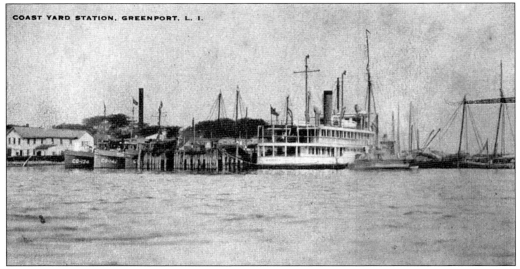

Coast Guard boats are tied up at the H.W. Sweet shipyard. In 1924, the federal government established a base in Greenport with the vessel *Wyandotte* serving as headquarters. During Prohibition, high-powered motorboats ran liquor into Greenport. The rumrunners would land at the shipyard north of the Greenport Basin & Construction Company, where they would be hoisted out to the water. The Coast Guard had no jurisdiction over high and dry boats. Prohibition brought a period of prosperity to Greenport. The workers in the shipyards would help unload the cargo, which was packaged in gunnysacks. They would receive a bottle of the contraband for their efforts. (CDJ.)

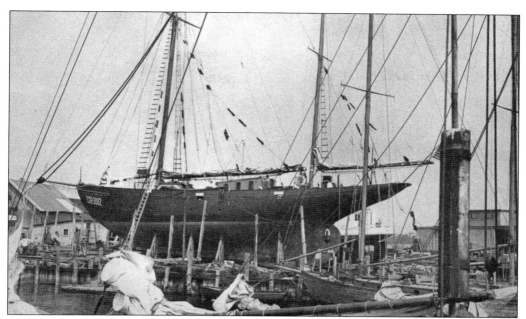

Pictured is the *Zaida* at a Greenport shipyard. The sailboat served in the Coast Guard Auxiliary Picket Patrol during World War II. The *Zaida* was lost in the Atlantic during an antisubmarine patrol, which prompted a massive search for the vessel. The vessel is used as a pleasure boat today and is a frequent visitor to Greenport Harbor. (SB.)

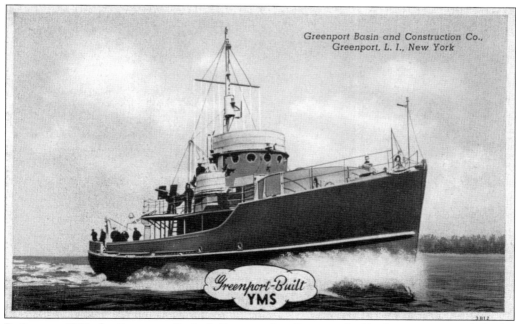

By January 1945, the Greenport Basin & Construction Company had built over 453 vessels for the military, including AMC 96-foot minesweepers, YMS 136-foot minesweepers, LCM (Landing Craft Mechanical) 50-foot (steel hulled), and YTB 110-foot harbor tugs. The yard had 1,115 workers and 60 subcontract workers with support personal for a total of 1,233 employees. (CDJ.)

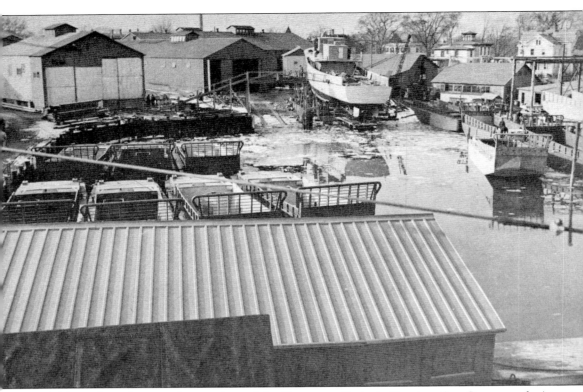

This rooftop photograph was taken of the Greenport Basin & Construction Company during the World War II period. A basin full of steel-hulled Landing Craft Mechanized. Over 403 of these welded landing craft were built by March 1945. The design was an evolution of the plywood-hulled Higgins boat. The Greenport Basin & Construction Company also produced conversion kits to change the LCM into fire and salvage craft. (CDJ.)

Seven

HOSPITALITY ABOUNDS

Greenport, since its earliest days, has hosted a range of visitors. Some people, like Col. George Washington, were just passing through. In 1757, Washington rode the length of Long Island into Stirling on his way to Boston and spent the night in the Constant Booth Inn. In the morning, he boarded a boat in Winter Harbor to take him across the Long Island Sound to Connecticut to continue his journey. As Greenport grew, tourists arrived and stayed in the fine hotels that also offered dining facilities. Job seekers, attracted by the opportunities offered in the maritime trades, boatbuilding and repairs, the railroad, and brick making found lodging and meals in the many boardinghouses in the village. Small luncheonettes appeared to serve the needs of working people. In the 20th century, Greenport became known for its fine restaurants, and after World War II, as automobiles travel grew, several motels emerged locally.

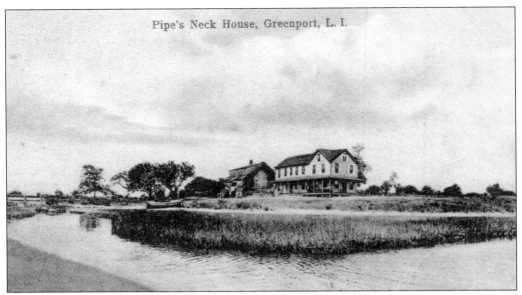

Pipe's Neck House, Greenport, L. I.

The Pipes Neck House was located off Pipes Neck Road on the western part of Greenport in the portion of Peconic Bay that was laden with the clay beds that supplied the brick–making industry. It was rebuilt in 1912 after the original house, constructed in 1812, burned down. The boardinghouse, originally owned by the Corwin family, was closed in the 1940s. (CDJ.)

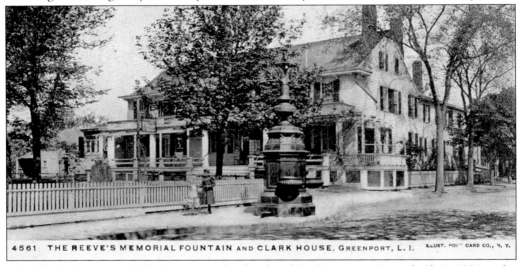

4561 THE REEVE'S MEMORIAL FOUNTAIN AND CLARK HOUSE, GREENPORT, L. I. ILLUST. POST CARD CO., N. Y.

The Clarke House on Main Street was the first hotel in Greenport. It was built in 1831 under the tutelage of Capt. John Clarke to host the captains and officers of the whaling trade and, after the decline of whaling, tourists. Originally, it housed a tavern when the area was named Stirling. In the early days of village, spirited community meetings were held there, and it was there the name of Stirling was changed to Green Port and, later, plans to become an incorporated village were made. In 1935, the Village of Greenport demolished most of the hotel, leaving the kitchen wing to serve as the village police headquarters until 1954, when the last portion of the once vibrant hotel was removed to make way for a municipal parking lot. The Margaret E. Ireland House, Greenport's Stirling Historical Society Museum, is now located on the site, and in its archive collection are several volumes of the Clarke House guest registers. (FML.)

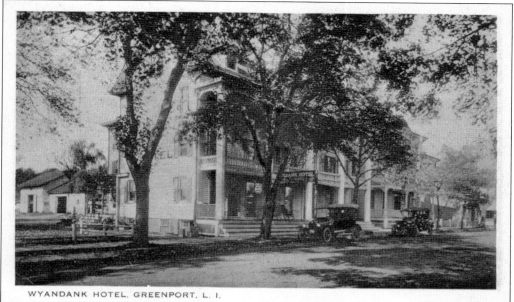

WYANDANK HOTEL, GREENPORT, L. I.

Railroad Avenue (now known as Third Street) once sported three fine hotels: the Wyandank, the Peconic Bay House, and the Sterlington. The Wyandank, built in 1840, was a popular tourist haven and had several owners, including one-time Greenport mayor Ansel Young. It was torn down in 1965. The Peconic House, built in 1845 by John Webb, was across the street from the Wyandank on the site where the Burton Potter American Legion Post and skating rink now stand. It was next to a pleasant waterfront park, where the Shelter Island Ferry Terminal is now located. The Sterlington, situated on the same side of the street north of the Wyandank, is the only one of the three hotels that still stands; however, it is now a Meson Ole Restaurant, displaying many enlarged vintage photographs of Greenport on its walls. In the later part of the 20th century, the Sterlington hosted the locally famous Jelly Belly Dart Club. (CDJ.)

The Griffing House was one of the fine, wood frame hotels located on Front Street in Greenport, with the Vienna Restaurant to its right. This 1900 turn-of-the-century postcard represents the first life of the Greek Revival building topped with a widow's walk. It later became the Hotel Dennis, followed by the Greenport House. (SB.)

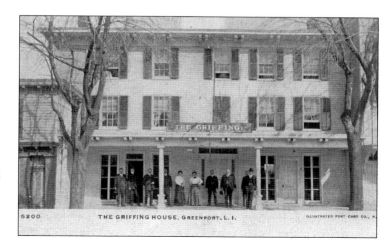

5200 THE GRIFFING HOUSE, GREENPORT, L. I. ILLUSTRATED POST CARD CO., N.

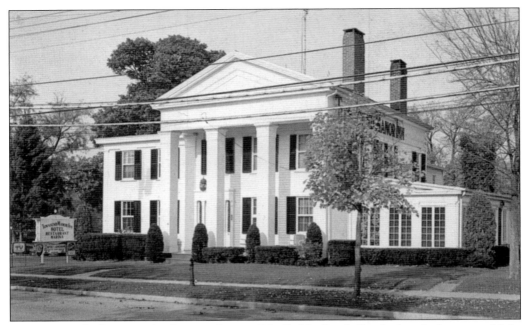

Prosperous whaling captain George Cogswell built his Greek Revival–style home on Main Street in 1835 and sold it in 1849 when he departed for California during the Gold Rush era. Lillian Cook Townsend, a local activist and suffragette, bought the property from one of the many successive owners in 1926 and restored and refitted it as Ye Olde Townsend Manor Inn. In 1954, the Gonzalez family bought the inn from the Townsends and renamed it the Townsend Manor Inn. (FML.)

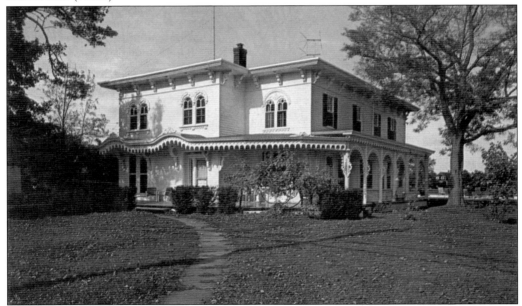

The Gingerbread House, built around 1858, is now part of the Townsend Manor Inn complex. It offers a unique use of Italianate elements. In the front doorway transom, it features rare, original stained-glass dark red and blue windows and cutout- and stencil-type designs. (CDJ.)

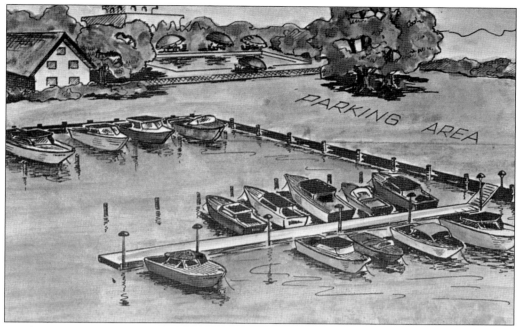

Frank Gonzalez began a vast modernization program in 1959, turning the Townsend Manor Inn property into a modern resort complex offering a marina with dockage, services, fuel for 52 yachts, and a swimming pool and snack bar to the existing restaurant, bar, and rooms. This is a postcard with a rendering of the dockside facilities in the planning stages. Now, during the slow winter months, Wooden Boatworks, located on Costello Marine's historic Hanff's Boat Yard that abuts Townsend Manor Inn on the waterfront, stores several of the classic wooden boats that they build, restore, repair, or maintain at the Townsend Manor Marina. (JM.)

Captain Jensen's house was added to the Townsend Manor Inn complex during its restoration. (CDJ.)

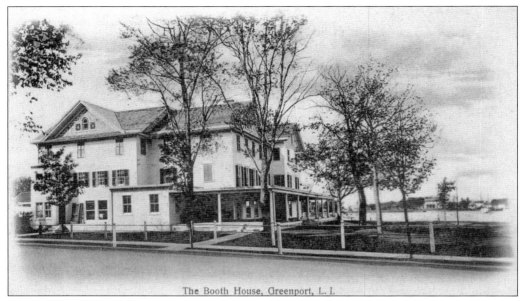

The Booth House, Greenport, L. I.

This c. 1930 view of the Booth House, built in 1877, was captured from Sterling Avenue and shows Stirling Creek in the background. The Booth House Inn was a three-story building with 40 rooms available for occupancy. (CDJ.)

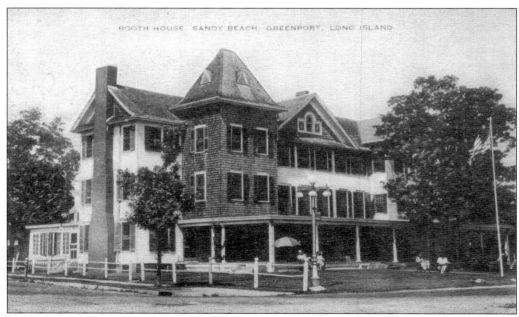

BOOTH HOUSE SANDY BEACH, GREENPORT, LONG ISLAND

A later view of the Booth House, as viewed from across the water on Sandy Beach, features the addition of a shingled cupola. The cupola was added at the same time as the chimney for a heating system. Central heating enabled the popular Stirling Creek hotel and restaurant, previously open only in the summer, to extend its business year to 12 months. (SB.)

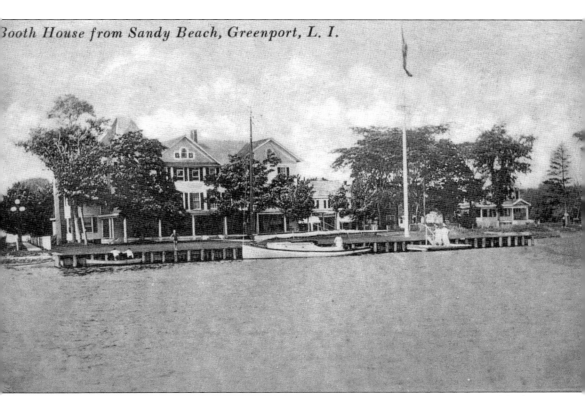

Booth House from Sandy Beach, Greenport, L. I.

The Booth House is pictured here in the 1940s. The Picket Patrol was established to enable the Coast Guard to recruit local vessels and men to man them to patrol the eastern Atlantic waters. It was believed that civilian boats would be less obvious in tracking the German U–boats boldly torpedoing US vessels bound to Europe conveying goods and supplies. The third Naval Picket Base was established in Greenport Harbor, and within a week, three boats—the *Sea Gypsy*, the *Edlu*, and *Sea Roamer*—stood out past the breakwater and Shelter Island for their first patrols. The Greenport branch, also known as Hooligan's Navy, rapidly grew with local recruits, all from Long Island, Connecticut, and New Jersey, who used the large Booth House as their base of operations. Hooligan's Navy eventually had 33 sailing vessels, 225 full-time temporary reserves (with no boot camp or training), and a few cooks. In February 1943, after the patrol was dissolved, the Booth House soon reopened as an inn. In ensuing years, it went through many changes of ownership, and in 1971, the historic hotel burned to the ground. The grassy stretch that replaced it is currently for sale. (CDJ.)

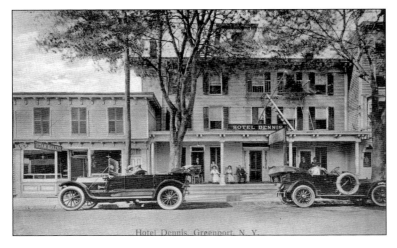

Hotel Dennis stands beside Star Bakery in this 1914 postcard that also features visitors enjoying their stay at the rechristened hotel and the unusual parking arrangement of two vintage automobiles on Main Street. In 1914, the neighboring Star Bakery was sold to Fred Hoefer of Brooklyn, New York. (SB.)

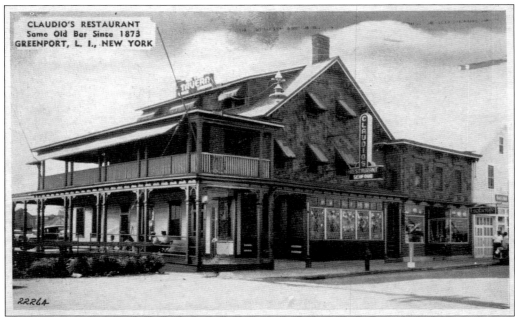

Manuel Claudio ended his career as a whaler in the 1870s when, having saved enough money after 16 years working on the *Neva*, the whaling ship that first brought him to Greenport from the Azores as a youngster, he was able to end his seafaring days and put down roots in the village. He was initially a liquor dealer on Main Street, and in 1896, he expanded his business by opening the Star Hotel. Around 1915, Manuel and his son Frank bought the Commercial Hotel from Mary Mott. Claudio's Restaurant is still situated here, and his descendants proudly serve visitors and locals alike at the Main Street Wharf restaurant In later years, the wharf was extended to include more marina space and casual dining. (SB.)

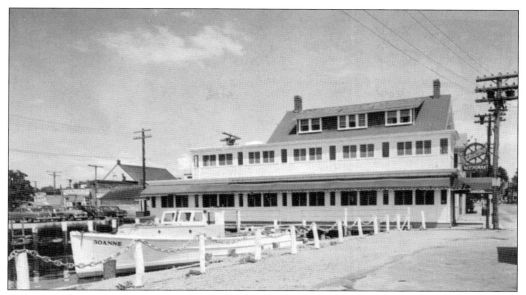

This view shows the modern configuration of Claudio's Restaurant with the deck and the area under it enclosed as well as a space towards the marina filled in. On a summer night, the area is teeming with people enjoying the food, fun, and music in the very special setting on Main Street Wharf. (SB.)

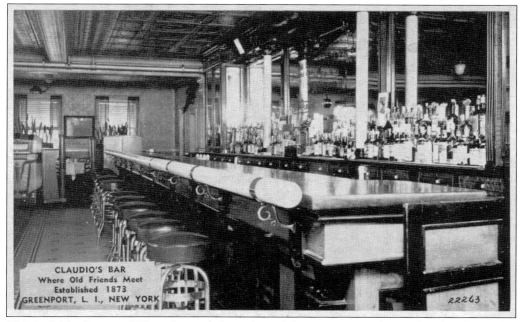

This is richly decorated Victorian-style bar salvaged from a New York City hotel and installed in Claudio's Restaurant. During the years of Prohibition, when bootleggers raced their boats into Greenport Harbor in the dark of night with their cargo, they glided under Claudio's bar and off-loaded the illegal booze through a trap door behind the bar, where it awaited the appropriate time to be transferred west of the area. One of these trap doors still remains and is used to service the utilities under the restaurant. (SB.)

THE LITTLE DIPPER - GREENPORT, LONG ISLAND, N. Y.

The Little Dipper was located on the Oak Grove Casino property at the end of Cherry Lane at Ninth Street in Greenport. It was the only restaurant in the area with enough seating available for the 167 air personnel participants and dignitaries attending the staged air disaster flight over a field on Mrs. Harrison McCann and Herbert Fordham's property in eastern Greenport. Prompted by the devastation by the Great Hurricane of 1938, several national and regional aviation groups planned the event under the direction of Joseph B. Hartranft Jr. of Southold, an Aircraft Owners and Pilots Association (AOPA) executive. Ruth B. Nichols, a famous record-setting aviation pioneer of the Relief Wings, led the way on a United Airlines transport plane at 8:00 a.m., with a medical staff and supplies on board, landed in Suffolk (Gabreski Airport) in Westhampton Beach to switch to a smaller, twin-motored Beechcraft, and arrived at the Greenport airfield. The flight took a total of 55 minutes. Ann Currie-Bell had this to say of the flight, which was also part of Southold Town's tercentenary celebration: "People were coming in streams from all directions; cars filled the roads; and again Southold Town Police, Legionnaires, State Troopers, Greenport Southold, Cutchogue and Mattituck Boy Scouts were on duty caring for the crowds and acting as ground crew for landing the planes. Not a mishap occurred." (RW.)

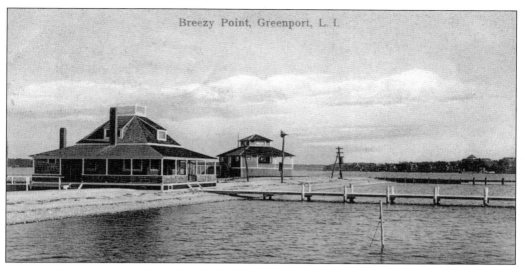

The Breezy Shores Cottages are located on Peconic Bay, off Sage Boulevard, in Greenport. The former beachfront cottages that housed workers from the Sage Brickyard were converted to 31 summer rentals by Walter Sage after the ferocious 1938 hurricane caused the bay to flood and destroy the clay banks that provided the material for the bricks. The 90 acres of waterfront property has since been sold. The cottages are now a condominium community, and the brickyard, originally founded in 1887 by Dewitt Clinton Sage, is now used as the Brick Cove Marina, which is owned and run by Howard and Dorothy Zehner. (SB.)

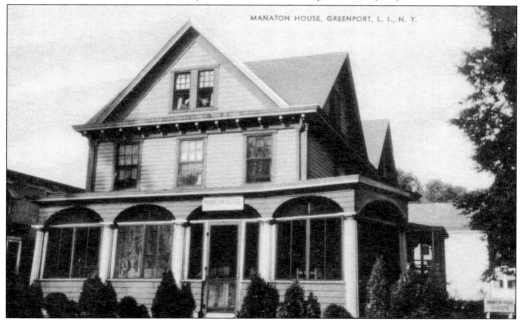

The Manaton House, located on the corner of First Street and Central Avenue, was operated as a boardinghouse for many years by Mrs. W. Manaton. Widows who fell on hard times often turned their homes into boardinghouses. Traditionally, such lodging offered a room and often breakfast and supper at a reasonable rate to single workers who fueled the lively local economy. This home burned down in the late 1980s. (RW.)

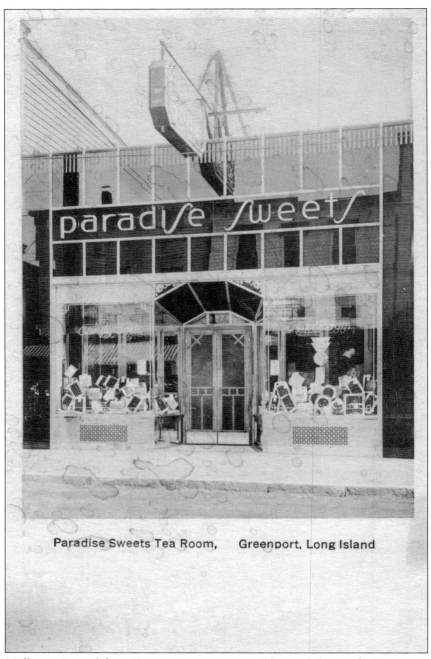

Paradise Sweets Tea Room, Greenport, Long Island

George Mellas emigrated from Greece as a teenager and learned the confectionery trade from his brother James. He opened the Paradise Sweet Shop on Front Street in 1923. They served breakfast, lunch, and dinner as well as homemade candy and ice cream. After a terrible fire caused by an accidental spillage of cooking oil, the Paradise, along with neighboring stores, was burned to the ground. It was the first fire where the Greenport Fire Department had to call for assistance from neighboring Southold Fire Department. The former wooden structure was quickly rebuilt and replaced with the brick siding shown in the picture above. (JMP.)

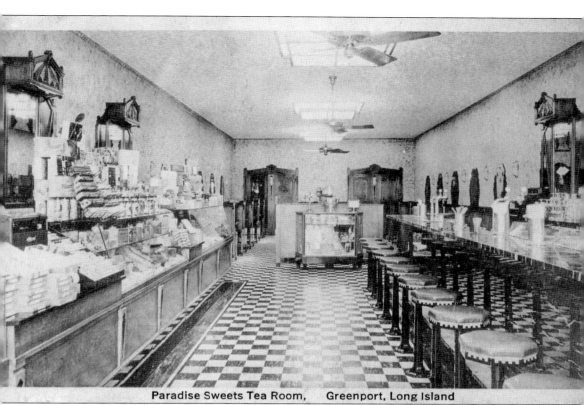

Paradise Sweets Tea Room, Greenport, Long Island

The popular Paradise Sweets, with its new interior, was open until late in the evening, providing a place for both old and young to congregate after an evening at the movies, the bowling alley, or dancing. Having purchased the business from George Mellas's widow, Peter Pappas ran the Paradise until 1980. Midway into the 20th century, Dennis McDermott opened the Frisky Oyster Restaurant, which, with its sophisticated lounge-like interior and excellent New American cuisine, was the hallmark of a new era of dining in Greenport Village. (JMP.)

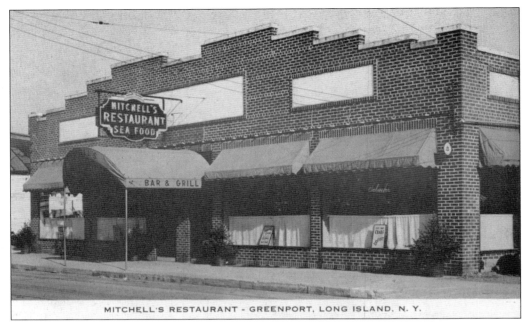

MITCHELL'S RESTAURANT - GREENPORT, LONG ISLAND, N. Y.

The original Mitchell's Restaurant was located on the site of a former service station and garage on Front Street in the middle of downtown Greenport. Harry Mitchell and Edward Seeley opened the restaurant there in 1933. (SB.)

Henry Mitchell eventually bought Campbell's Ford car dealership to the west and expanded his restaurant to include a large banquet room. On the east side, he bought another piece of land and built a 16-unit motel. (CDJ.)

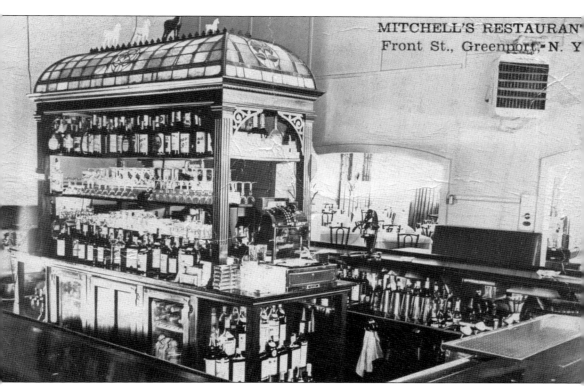

MITCHELL'S RESTAURAN'
Front St., Greenport - N. Y

The bar at Mitchell's Restaurant was a much frequented, vibrant spot in the community of Greenport; often, during the off season, one could find a local bayman who just delivered his days harvest to Mitchell's kitchen having a short one at the bar with many of the local businesspeople, who were enjoying the dollar businessman's lunch and sharing the local news. During the tourist season, the bar was jumping, and Harry Mitchell, John Cowan, Scotty Campbell, and Ray La Riviera deftly served all who came with a smile, wisecrack, or joke. The oversized photographs of Greenport scenes on the walls were in juxtaposition to the canopy bar that Harry Mitchell bought from the former Gings Saloon on Main Street. (CDJ.)

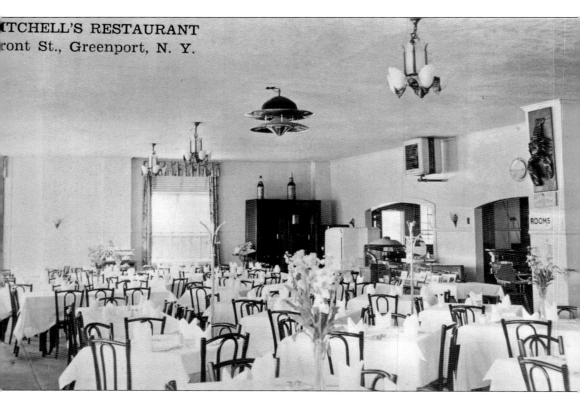

ITCHELL'S RESTAURANT
ront St., Greenport, N. Y.

The dining room at Mitchell's Restaurant was simply appointed with white cloth napkins and tablecloths, simple china, and silverware; the large windows capturing the comings and goings on Front Street supplied the visual effects. Under the robust leadership of the diminutive Pauline Mitchell, the well-trained staff delivered the food from the menu of sundry offerings promptly and graciously. One could gaze across the room and see one of the local lobstermen and his family on a special night out, while at a nearby table, matinee idol Van Johnson would be enjoying his visit to the east end and a dinner in downtown Greenport. (CDJ.)

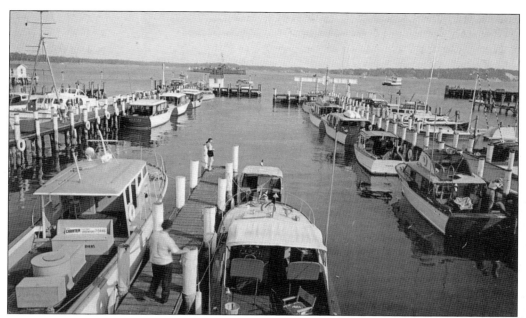

The Mitchell Marina was later addition to the Mitchell family business. Over time, they purchased seven pieces of property on the waterfront to create a comprehensive business complex in the heart of the Greenport business district. Looking at the 3.2 acres that comprised that area on the 1887 Sanborn Insurance Map on page 2, one can see the same area intensely developed with marine businesses and industries that all supported the shipbuilding and marine trades. Commercial boat and fishing activities predominated the waterfront in what became downtown Greenport in 1827, when Main Street was extended to reach the deepwater port on the south side of Greenport. (CDJ.)

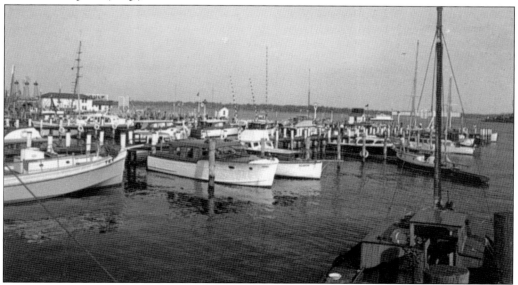

Locals also enjoyed visiting the Mitchell Marina to check out the visiting boats, enjoy a stroll on the docks, or to just hang out for a while, and often, they brought along a fishing rod to catch a fish or two. (CDJ.)

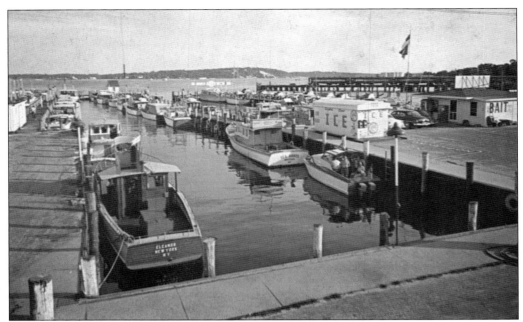

The full-service marina with a bait shop, icehouse, and the dockmaster's house offered everything anyone traveling by water could wish for, including a fine restaurant. During the boating and fishing season, the Mitchell's 130-boat-slip marina was filled with boats of all descriptions: motor and sailing, pleasure boats, fishing and baymen's crafts, and open boats. They came from all over, including locally, to tie up at this fine boat landing. (DC.)

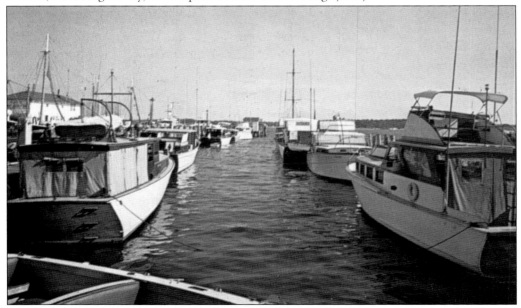

On November 7, 1978, the land portion of the Mitchell property burned to the ground and a pall fell over the community. Over the years, several business ventures were brought forth to redevelop the property, but none proved viable, and the community lived with a disrupted, neglected region in the most visible area of its downtown. (CDJ.)

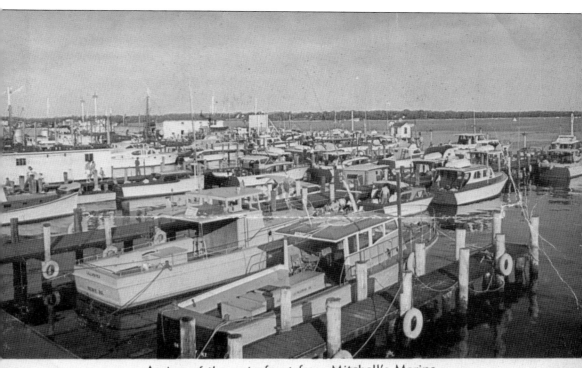
A view of the waterfront from Mitchell's Marina

Today, with a different configuration of the docks and of land use, the Village of Greenport has created a gathering spot for locals and visitors in Mitchell Park (opened in 2001) and the marina (opened in 2007). The Northrup/Grumman Carousel is the centerpiece of the park, which also features a camera obscura, an amphitheater, a well-staffed marina building that offers a second-story viewing deck of the bay, showers, experienced deckhands, and other amenities. In the winter months, the ice-skating rink attracts eager skaters and several ice hockey teams. The park is a popular place for public dances with live bands, an annual Shakespeare festival, and the Christmas tree lighting and menorah lighting as well as many other activities such as the Greenport Maritime Festival and a boat show. The Harbor Walk that spans the water side of the park west to the Shelter Island Ferry slip provides a great view of the boats in the marina and the activity on Peconic Bay. (CDJ.)

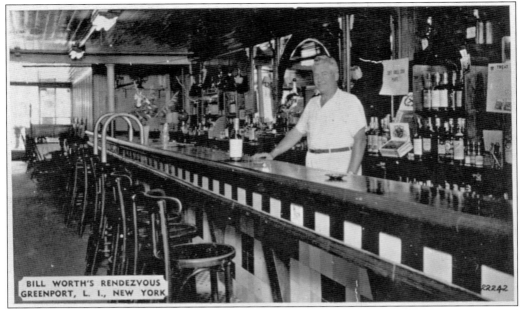

BILL WORTH'S RENDEZVOUS
GREENPORT, L. I., NEW YORK

Bill Worth's bar Rendezvous opened in the village after the Volstead Act was repealed and Prohibition had ended. Worth was a convivial barkeep, and his bar was very popular with fisherman and sailors. (SB.)

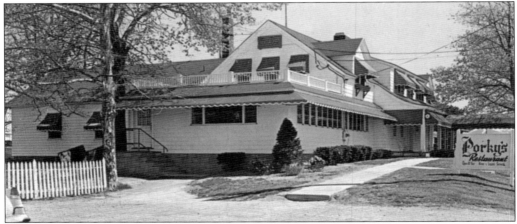

Walter "Porky" Sledjeski relocated his restaurant from the Mill Creek Inn on the Peconic Bay waterfront in Arshamomogue to this site on the North Road in 1950. In the new Porky's Restaurant, he and his wife, Sophie, continued to serve "good local food, beef to seafood and everything in between" for which they were known since they went into business in 1937. Porky and Mitchell's restaurateur Harry Mitchell were the best of friends. Harry was tall and thin and always wore an apron, and Porky was tough; according to those who knew him, if someone looked at him wrong, he would throw them out of his restaurant. Porky, however was always welcoming to the local kids who would sleigh down the hill behind his restaurant during snowstorms. Their restaurants had similar menus; although Mitchell's was larger, every spring, they would sit down and discuss the upcoming season's offerings and prices, so as not to hurt each other's business. The Sledjeskis' son Richard became the owner of Porky's in 1962, and the restaurant closed in 1995. (SB.)

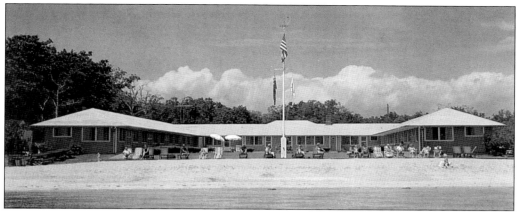

The sand in front of the 22-room Silver Sands Motel is fine-grained and glistens in the sun, offering a peaceful, natural setting to relax and enjoy the expanse of Peconic Bay with Shelter Island across the way. It was founded in 1961 by Thomas and Florence Jurczenia, and the couple initially offered guests a traditional lobster bake on the weekend. Described as "retro" by their children who now run the motel, the lobby has a collection of maritime art that includes two models of whaling ships made by their captains. On the east side of the property, the family has an expanse of wetland meadows preserved as the Thomas Jurczenia Wildlife Sanctuary, which also supports the Pipe's Cove Oyster Company, part of the SPAT program. Recently, an elderly woman came into the motel, pointed to the child on the right in the postcard above, and said, "That's me." (SB.)

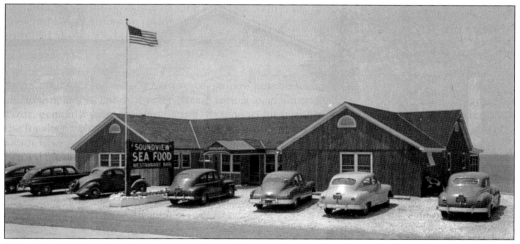

When Joe Wielandt of Greenport left the Wyandank Hotel in the mid-1940s to build his own restaurant, he and a partner bought a narrow strip of waterfront land with an operating hot dog stand. Located in western Greenport on Route 48 with a stunning view of Long Island Sound, the hot dog stand was soon replaced with a simple, weathered, gray one-story building that offered a great view of the water. The Soundview Restaurant offered a welcoming bar under the direction of new partner Ed Speeches and bartender Henry Stepnoski of Greenport as well as an excellent menu that included the best of local seafood prepared under the direction of Chef Joe Wielandt. Soundview's interior was simply decorated with large paintings of area fish on the interior dining room walls. Weiland and Speeches sold their restaurant to their neighbor Jack Levin, owner of the Sound View Inn, in 1968, and he expanded the waterfront seating capacity on the east side of the building, enabling him to host banquets in the restaurant. (CBJ.)

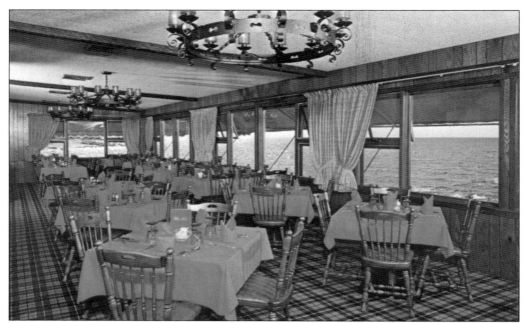

In 1953, Jack Levin, proprietor of Jack's Shack on Southold Town Beach, built the Sound View Inn just west of Soundview Restaurant, and his wife, Donna, managed it. As the Levin family grew to four children, in 1955, Jack left the Jack's Shack to help run the popular motel. (SB.)

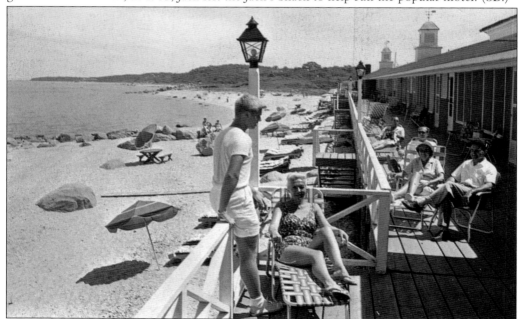

The stunning view of the Long Island Sound was used as a magnet to attract guests to the motel rooms, as was the Soundview Restaurant next door, which offered great luncheon and dinner fare. When guests tired of swimming and sunning, they could walk across Route 48 for a game of tennis on the newly built courts or hop in their cars to explore the diverse hamlets of the eastern end of North Fork. (SB.)

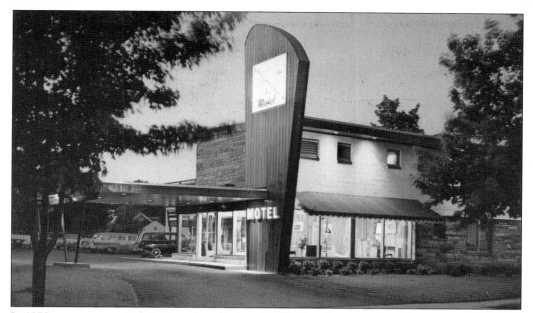

In 1958, entrepreneur Jack Levine, the self-described "oldest Greenport Jewish person still around," returned to his nearby hometown to build the Greenporter Motel on Front and Fourth Street at the entrance to the village coming in from the west. Debra Rivera bought the motel 1990 and, utilizing the vacant land on the property, built and opened the Greenporter Hotel & Spa, which features an outdoor swimming pool and the Cuvee Grill and Seafood Restaurant. (SB.)

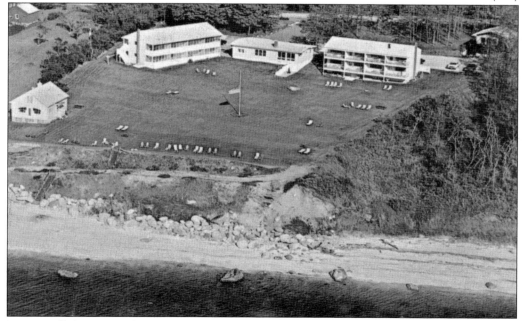

To cap off their contribution to the food and resort community, in 1972, the Levin family purchased the Sunset Motel to the east of the Sound View Inn from then owner Verna Molin. The motel, set on a spacious piece of land buffered from the road, also offered a breathtaking view of the Long Island Sound. (SB.)

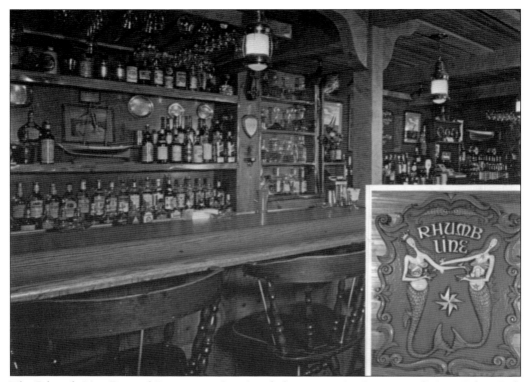

The Rhumb Line Bar and Restaurant sign signaled a new era in Greenport dining. When Bob and Carol Copas purchased the building on Front Street in Greenport in 1974, they bought the old wooden structure that had formerly housed Steve's Vienna Restaurant and Hotel and, after that, Helens Hotel and Bar. The Copas were avid sailors and kept their sailboat at Henry Pierce's shipyard on Stirling Creek. Bob, a fine broth of a man, admired Mitchell's Restaurant and its food, drink, and welcoming attitude towards sailors and their families, and he modeled that atmosphere in his restaurant. He demonstrated it in his renovations, and the Rhumb Line heralded a new wave of restaurants, including Jacobs Larder, located in the recently renovated Sterling Square, the site of the former Arnott's Drug Store, and featuring the cuisine of French chef Robert Hascoat and Doug Jacobs. Daughters Karen and Jackie ran the restaurant after Bob and Carol retired in 1987 and eventually sold the restaurant in September 2011. The latest owners decided to once again use the original name of Rhumb Line. (JC.)

The Bartlett House, donated to St. Agnes Church by the Thornhill family, served as a residence for teacher nuns when the Catholic Church operated a grade school nearby for several years. Now known as the Bartlett House Inn Bed and Breakfast, it was one of the first such homes catering to visitors to open in the Greenport community and is still a popular establishment. (CDJ.)

Eight

Churches, Schools, and Eastern Long Island Hospital

As Greenport developed into a prosperous whaling port in the early 1830s, it attracted a diverse group of people who came here to work on the marine trades and, later, the brickyards and the railroad. Many arrived on ships from ports around the world and settled in the village, assimilating into the community. Newcomers gathered with their fellow immigrants frequently, clustering around the religion they brought with them from their homeland, and they met in other denominations' churches until they were able to build their own places of worship. Regrettably, the authors were unable to locate a postcard of the Congregational church on First Street and several mission churches that no longer exist, but there are several houses of worship that are still vital parts of the community: the Congregation Tiffereth Israel Synagogue on Fourth Street, the Clinton Memorial AME Zion Church on Third Street, and the Shiloh Baptist Church on Route 48. Early in its history, Greenport had a large mix of religious buildings. Heading north on Main Street while leaving the shopping area yields a view of a number of church steeples. Schools were also important, and as the community grew, so did the number of school buildings, until the district consolidated to one structure in 1932. Early on, the community recognized the need for a hospital, and the Eastern Long Island Hospital, the first hospital in Suffolk County, was erected.

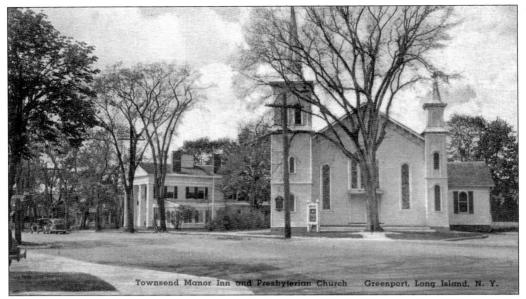

Townsend Manor Inn and Presbyterian Church Greenport, Long Island, N. Y.

The Presbyterian Church, located on Main Street next to the Townsend Manor Inn, was a direct result of the area's Puritan roots and was dedicated in 1835. In the late 1970s, the congregation had dwindled, and the venerable church closed and was sold. In 1981, the church was rededicated as the new home of St. Anargyroi and Taxiarhis Greek Orthodox Church. The interior has been renovated in the traditional Greek Orthodox style, and the exterior has maintained the look of the former Presbyterian church, with the addition of a large, circular icon over the entry. (CDJ.)

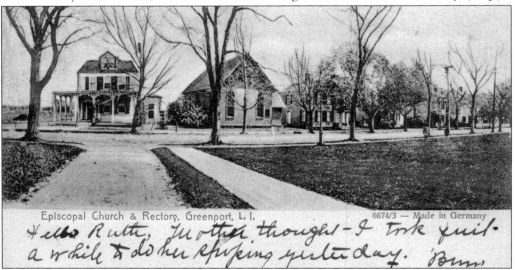

Episcopal Church & Rectory, Greenport, L. I. 6674/3 — Made in Germany

Holy Trinity Church, shown here with its rectory, was organized in July 1863, and the first services were held in a cottage behind the Wyandank Hotel and then moved to the Stirling Academy. The current church was built in 1865, and services were held there in July of that year. Originally considered a summer parish, the church was closed during the winter season due to lack of heat. Eventually, the church was renovated, and it became a year-round parish. Over the years, the church hall has been used by Alcoholics Anonymous, a church-sponsored play school, local theater groups, and the Boy Scouts. It frequently has hosted church-sponsored suppers. (CDJ.)

The Baptist Church was organized in 1831 and met in a house on Sterling Street. The church, pictured at right, was the first to be built in Greenport in 1832 on the corner of the North Road and Main Street and was moved to its current Main Street location near Sterling Street and expanded in 1845. The Fellowship Hall was added, and the parsonage was built in 1871. The church has a unique interior with a large pipe organ behind the altar and four Tiffany windows visible only from the interior on the northeast side of the church. The Neoclassical front porch was added in the 1930s. (CDJ.)

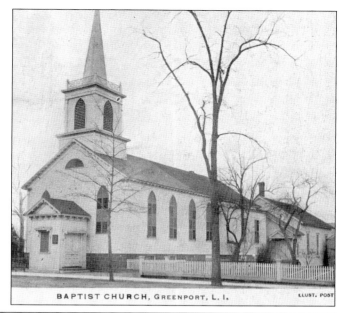

BAPTIST CHURCH, GREENPORT, L. I. ILLUST. POST

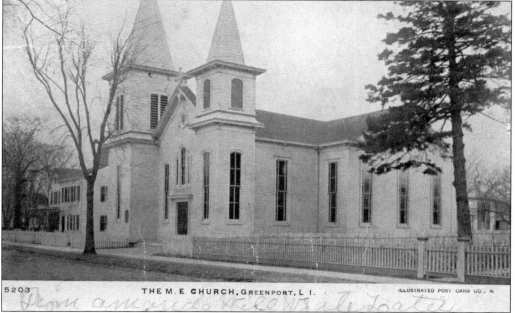

5203 THE M. E. CHURCH, GREENPORT, L. I. ILLUSTRATED POST CARD CO., N.

The first Methodist congregation in Greenport was formed in 1828 and met in the Baptist church. In 1832, a meetinghouse was erected on Main Street, across the street from the Baptist church. It was dedicated in 1834. Rebuilt after a fire in 1847, a large chapel and lecture room was added to the western end of the church in 1858, and in 1878, the parsonage on First Street were added. The old church was dismantled in 1890 and replaced by 60-foot-high spire that featured a vane and a ball that was created from a mast of the USS *Ohio*, which was sunk in Greenport Harbor. The church lecture hall has often been the place for delicious church suppers, summer Bible school, Stirling Player's productions, and antique shows and is the meeting place of the Stirling Historical Society. (SB.)

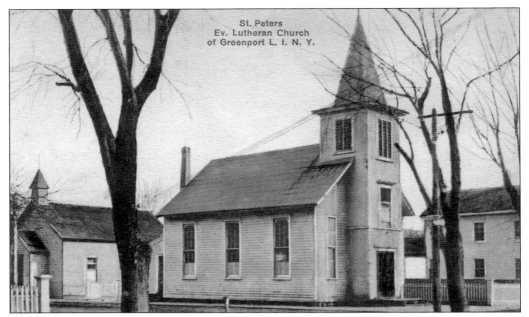

In 1839, the German population met as a Lutheran congregation in the Congregational church, then located on the property of the Floyd Memorial Library. Rev. John Peter Drach, an ordained Lutheran minister from Hannover, Germany, purchased a piece of property downtown and ran a cigar store there as well as ran a Lutheran Sunday school. Later, his grandson Reinhold Tappert sold books, stationary materials, and had a Western Union office there. Reverend Drach, who immigrated to the United States in 1877, was instrumental in building the small Lutheran church on Fifth Avenue in Greenport. In the early 1960s, the Lutheran Church purchased land of the former Skyway Drive-In Theater just west of the village and built a new church. Bill and Walter Hanff, then the owners of Hanff's Boat Yard, whose family had been parishioners for years, took the plans they had for a traditional whale boat and built the bow true to scale to serve as a pulpit; it was a perfect fit with the church's maritime-inspired design. (CDJ.)

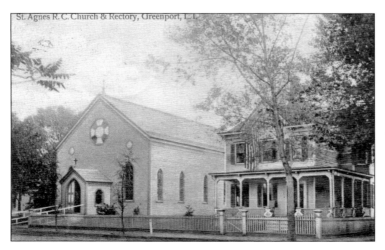

The early parishioners of St. Agnes R.C. Church in Greenport were primarily Irish, and they came to Greenport to work on the railroad. Originally, they met in each other's homes, but in 1855, they had enough money to buy land and build this modest clapboard church and rectory that faced Front Street near the corner of Sixth Street. (CDJ.)

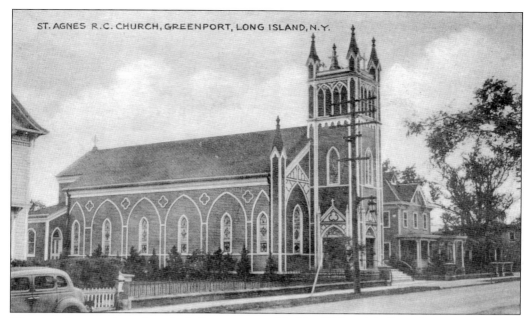

The church was enlarged, and a bell tower was added in 1882 and dedicated in 1884. In 2009, the church bell tower, windows, and facade were renovated, and a small chapel and a handicap accessible restroom were added. On Saturday evenings, there is a mass in Spanish for the Latino community. (CDJ.)

In 1960, St. Agnes Grammar School opened on Front and Sixth Streets across from the church. The modern, one-story brick building once housed classrooms, an auditorium, and staff offices, and a shrine to the Blessed Virgin Mary graced the Front Street lawn. Now closed, the former school building currently houses the catechism and CCD classes, Hispanic Apostolate, John's Place Homeless Program, a soup kitchen, a well-appointed church gift shop, and space for church meetings and other community activities. (CDJ.)

88 • THE GRAMMAR SCHOOL AND KINDERGARTEN, GREENPORT, L. I.

ILLUSTRATED POST CARD CO

arrived safely. I had a very nice time. We all send Love, From Dorothy Wells.

The small wooden building on the left was constructed in 1818 and served as the school for the children from East Marion, Arshamomoque, and Stirling (Greenport). A larger school was built in downtown on First Street in 1832, and the students transferred there. A new school, at right, was built in 1879 to accommodate the growing number of students. In 1889, when the district established a kindergarten, the small wooden school was moved from its original site on the North Road (Route 48) to the Lily Property on Fourth Avenue and South Street and was used as a kindergarten until 1932. It has since been relocated to Front Street and beautifully renovated; it is now open for community meetings and activities. (CDJ.)

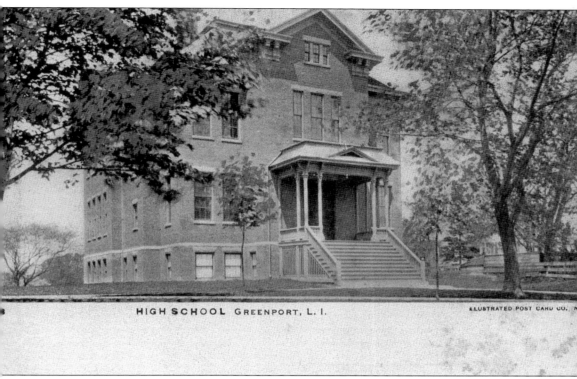

HIGH SCHOOL GREENPORT, L. I.

In 1880, the first class entered the new, wood framed structure, and in 1881, the first class of nine students graduated. (CDJ.)

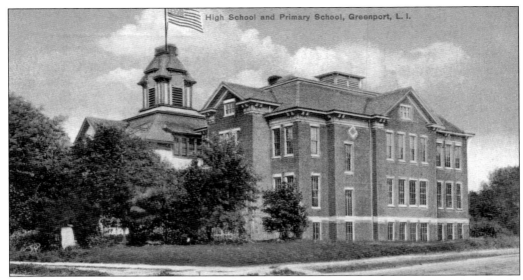

As business and population grew in Greenport, so did the need for more space in the schools. In 1905, the school district added a separate high school, and in 1910, a brick building was constructed to house the primary grades. Subsequent uses of these buildings were ended, and the structures were torn down to make way for the Greenport Fire Department's fire station, which consolidated all fire companies, excluding the Standard Hose Company No. 1. That company remains in its original building across the railroad tracks on Flint Street, strategically situated to serve the homes south of the tracks if the rails are blocked by a train. (CDJ.)

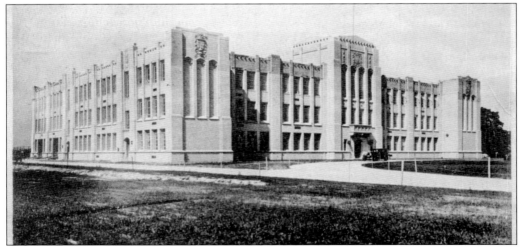

In 1931, noting the need for a new building with a gymnasium and central heating, among other things, the school board petitioned to construct a modern school plan. The Price property, just west of the village, was purchased for the relocation. D. Stanley Corwin was the president of the board of education at the time, and after months of legal delays, the board and the architectural firm of Tooker & Marsh were congratulated by the New York State Education Department for the finest, most modern, and most complete school plans in the state. The kindergarten, elementary, and high schools were moved to the current location in 1933. The Greenport Union Free School District also serves students in grades 7 through 12 from the Oysterponds School District, comprised of children from East Marion and Orient. (CDJ.)

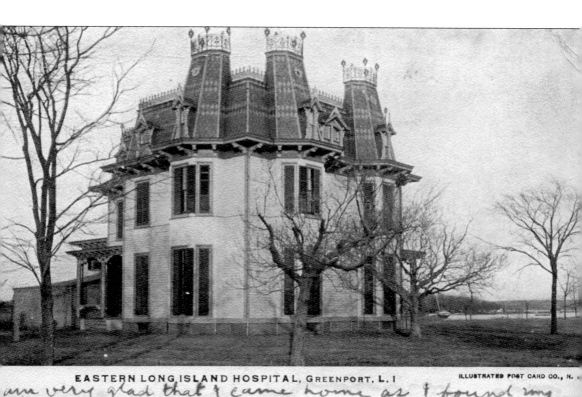

EASTERN LONG ISLAND HOSPITAL, GREENPORT, L. I ILLUSTRATED POST CARD CO., N. V

am very glad that I came home as I found my
ther ill. He is better now. Have a good time E S W.

This mansion and five acres of land situated on a spit of land at the head of Stirling Creek known as Monsell Place was bought by A.C. Sully, proprietor of the Greenport House, in 1890. In 1905, subsequent owners the Wood sisters donated the mansion and land to the previously formed Eastern Long Island Hospital Association. In 1913, they deeded it over to the association. The hospital was second to Mineola on Long Island and the first in Suffolk County. The first medical staff consisted of Drs. Benjamin, J.N. Hartranft, C.C. Miles, and B.D Skinner. (DC.)

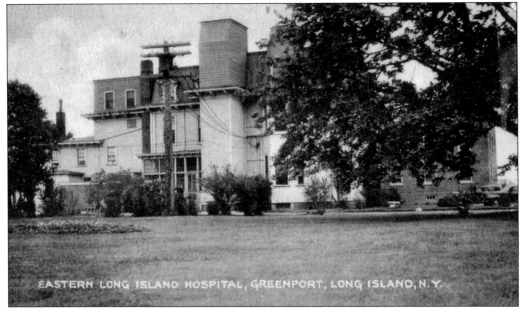

This 1932 postcard of the hospital shows, on the right, the addition of the children's ward and a delivery ward. (RW.)

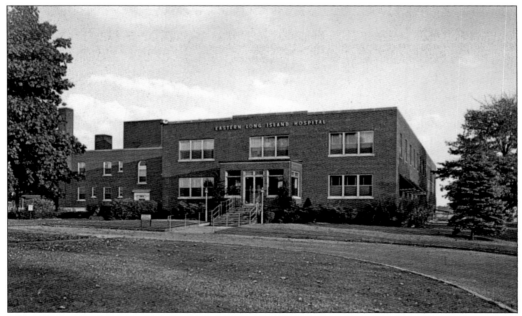

The old wooden building that served Eastern Long Island Hospital for so many years was finally torn down in 1949. Since then, the fireproof brick facility, with many additions to the physical structure and medical equipment, has continued to provide the people in North Fork and Shelter Island with excellent medical care. Along with expert equipment and well-trained doctors, nurses, technicians and other personnel, there is a helipad for helicopters to land on to pick up and transport critically ill patients for highly specialized treatment in other facilities. (DC.)

Nine

THE WATERFRONT

With the ending of the Pleistocene period 10,000 years ago, the last glacier left behind the Harbor Hills moraine, which formed Greenport Harbor, Stirling Creek, and other small creeks in the area. The natural beauty of the original Stirling Creek can only be imagined. The west arm of the creek ran past present-day Bridge Street, and the east arm ran almost to the present-day Main Road. Small creeks like Widows Hole dotted the shoreline. The aboriginal Indians' life was integrated with nature, and the bountiful waterfront supplied copious amounts of fish and shellfish.

The coming of the English settlers brought inevitable development and change began. The logical place to start a settlement was at the mouth of Stirling Creek. Slowly the face of the waterfront was changed with a landing at Stirling Creek, then a wharf comprised of the only material available: oak piles cut from the woods. The Stirling Creek pier was eclipsed by the Central Pier at the foot of Central Avenue. With the laying out of Main Street, the next move was to the south end of Main Street with its access to deeper water.

Green Hill at the east end of East Front Street was excavated and used to fill in ponds and depressions. Bulkheads were built to protect the shoreline from erosion and allow vessels to load and unload directly to land. The bulkheads evolved from oak piles to treated lumber. As old bulkheads decayed, new ones were constructed in front of the old, and the shorefront was gradually advanced with fill where once there was sandy beach. One of Greenport Harbor's attractions was the deep water that allowed sailing ships to anchor close to shore and use lighters to load and unload.

The expanding waterfront served the boatbuilders, fishermen, traders, and travelers that made the growing village a commercial hub. The early village was tied to New England, which was a short sail across the sound.

A small community that engaged in farming, fishing, trading, and boatbuilding was transformed with the adoption of whaling as a trade, which generated shipbuilding, hotels, suppliers, and shops. The commercialization of the steam engine and the coming of the Long Island Rail Road in 1844 were events that expanded the growing village. Now more travelers and vacationers from the big city were added to those frequenting the waterfront.

Over the years, Greenport's waterfront has hosted sailing ships, whalers, submarines, Navy and Coast Guard ships, a Liberty ship, and the ever-present pleasure boats. And Greenport waterfront's contributed to two world wars with the construction of mine sweepers, tug boats, and landing craft. Today, the waterfront has turned into a pleasure-boat destination and a tourist attraction with a thriving restaurant industry.

If one looks into the future with the promise of rising sea levels, one thing is certain: Greenport's waterfront will change, adapt, and always be the center of activity.

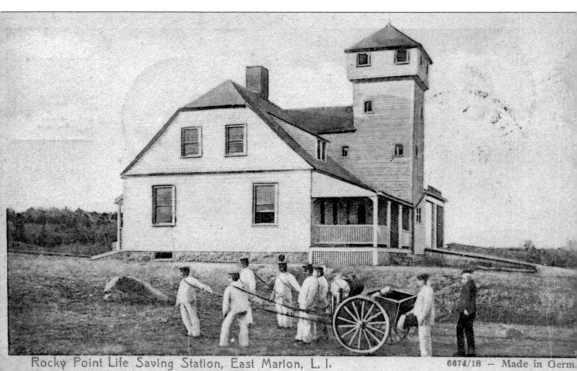

Rocky Point Life Saving Station, East Marion, L. I.

6674/18 — Made in Germ.

Dear Mrs B. Yours Received all O.K. — My Wife won't let me. W. Ho

The Rocky Point Lifesaving Station was built on Rocky Point Road in East Marion in 1886. The members of this early Coast Guard routinely risked their lives in treacherous maritime rescues. The rocky Long Island Sound coast of eastern Long Island was fraught with boats ensnared by the rocks of glaciers left long ago and the strong tides, waves, and storms. This station has been converted to a private home. (CDJ.)

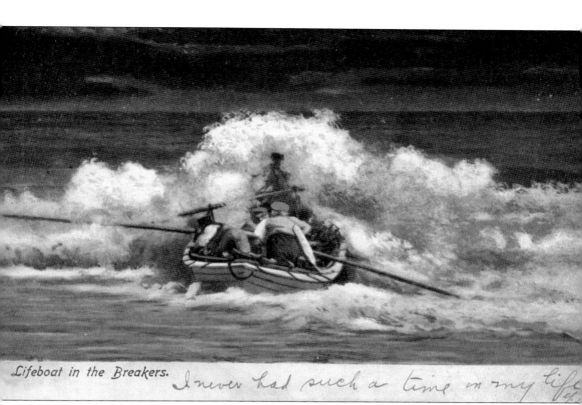

Lifeboat in the Breakers. I never had such a time in my life

This image of a lifesaving boat in the breakers shows an example of the wild seas the personnel faced heading into a rescue. (SB.)

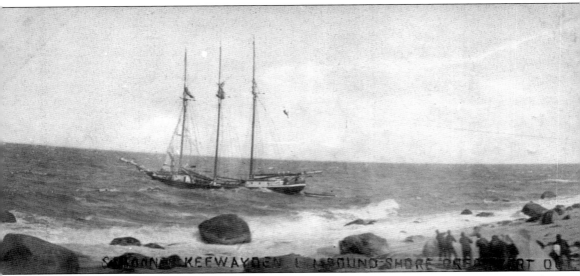

The British schooner *Keewaydin* was wrecked on the Long Island shore of Greenport in October 7, 1906, when her anchor dragged her into the rocks during a gale. All five members of the crew were rescued, four of them with a breeches buoy. The report is from the Rocky Point Lifesaving Station logbook. (SB.)

DECK COMPARTMENTS
WATERTIGHT DECKS

...LAST TANK
...LING PUMP
WATER BALLAST TANK
WATERTIGHT COMPARTMENTS
WATERTIGHT DECK

DECK COMPARTMENTS

FREEING TRUNKS WATER BALLAST TANK

COURTESY OF THE UNITED STATES COAST-GUARD

... 3.——PROFILE AND TWO SECTIONS OF 25 FT. 6-IN. SELF-BAILIN...
...RF BOAT (MODEL H)

The Beebe–McCellan lifesaving boats were built in the company's shipyard on Ludlum Place in Greenport from 1879 to 1918 and were a staple of the early US lifesaving services, which rescued people from shipwrecks off the coast of the United States. Frederick Chase Beebe was a former owner of the Shelter Island Ferry Company and an early director of the lifesaving services, and Capt. C.H. McClellan designed what proved to be the best design for such boats. The record of the Beebe–McClellan boats' efficacy affirms the choice; in the 18 years the boat were in service, they launched 6,730 times in actual service and rescued 6,735 persons from wrecked vessels. During this period, the boats capsized a mere 14 times and only six lives were lost in these instances. The above postcard is a prototypical design of a lifesaving boat. (CDJ.)

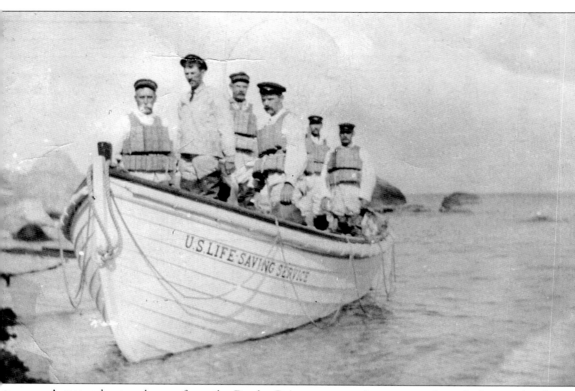

A rescue boat and crew from the Rocky Point rescue station are seen here during a calm day on the Long Island Sound. (AP.)

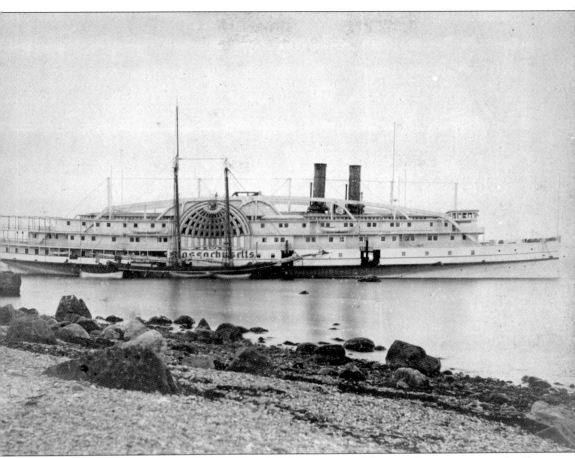

The Stonington Steamship Company's steamer *Massachusetts of the Providence* ran aground off the Long Island shore of Greenport. The *Massachusetts* made a daily run between Providence, Rhode Island, and New York City. (SB.)

Long Beach Bar Light, Gardiners Bay, Long Island, N. Y.

The Long Beach Bar Lighthouse was located in Gardiners Bay near the entrance of Peconic Bay. It assumed the nickname "Bug Light" because the original screwpile construction with the iron legs, in a distance, had the appearance of a giant bug on the water. The name stuck, and the lighthouse, first lit in 1871, is still commonly referred to as Bug Light. In 1963, the two-story white frame house with the mansard roof and attached tower was torched by arsonists and destroyed. (SB.)

The community mourned the loss of "Bug Light," both its presence in the harbor and the protection it offered to mariners. The surviving foundation was a bitter reminder of what was and what had happened. However, it also served to spur the formation of a large community group that assembled under the leadership of Merlon Wiggins, with his wife, Isabelle, assisting, that worked with government officials and the US Coast Guard to obtain permission to replace the light. Buoyed by the financial and kind generosity of the people of North Fork, the structure was rebuilt at the Greenport Yacht & Ship Building Co. grounds, transported by a Molloy dredging barge from Connecticut to be mounted on the original foundation in 1990, and was reactivated as an aid to navigation in 1993. Today, the East End Seaport Museum in Greenport controls and maintains the Bug Light. (FML.)

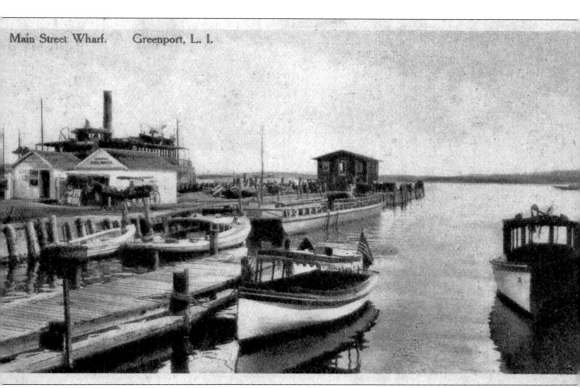

This is a view of the Main Street Wharf, situated at the south end of Main Street. The first wharf was built in 1828. Prior to 1828, the wharf at Sterling Street, followed by the Central Pier at the end of Central Avenue, were the centers of activity. The Main Street Wharf had the advantage of proximity to deep water. The Shelter Island ferryboat *Menantic* is in the Main Street ferry slip. The sign on the shack offers "Soda Water." (SB.)

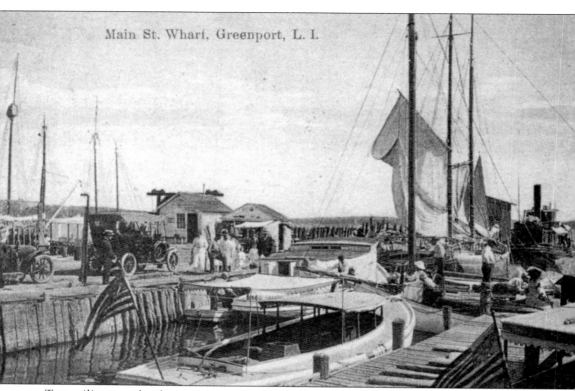

Main St. Wharf, Greenport, L. I.

Two sailing vessels, along with gasoline engine boats, are tied up on Main Street Wharf. The ladies, dressed up in their Sunday best, are ready for a sailboat outing. (SB.)

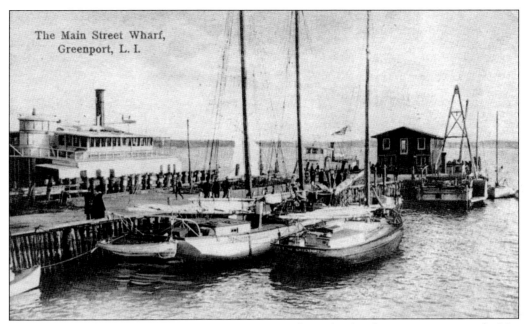

The Main Street Wharf,
Greenport, L. I.

The ferryboat *Menantic*, pictured at the Main Street ferry slip, has been given a coat of white paint in this postcard. A steam-powered floating derrick with side-wheel propulsion is tied up to the right in the postcard. (SB.)

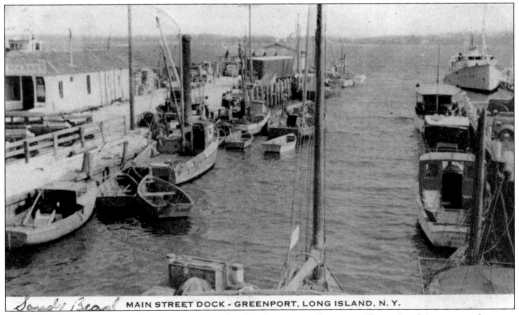

MAIN STREET DOCK - GREENPORT, LONG ISLAND, N. Y.

Time marches on for the Main Street Wharf. There is only one sailboat in this postcard; most of the power is now supplied by petroleum. Fuel storage tanks are visible in the middle of the photograph. The boat with a smokestack to the left of middle is still hanging onto coal and steam. (SB.)

An orca or killer whale is beached on the wharf west of Main Street Wharf. The whale washed up in Orient in January 1944. It was towed to Greenport and hauled out as an attraction. Prof. Charles Davenport, the director of the Cold Spring Harbor Laboratory and cofounder of the Cold Spring Harbor Whaling Museum, came to Greenport and cut the head off the whale. He then took it home and boiled the meat off the whale to get the jawbone. Professor Davenport died from pneumonia in February 1944. Cold Spring Harbor legend has it he contracted the pneumonia from working on the whale. The jaw can be seen at the Cold Spring Harbor Whaling Museum. (SB.)

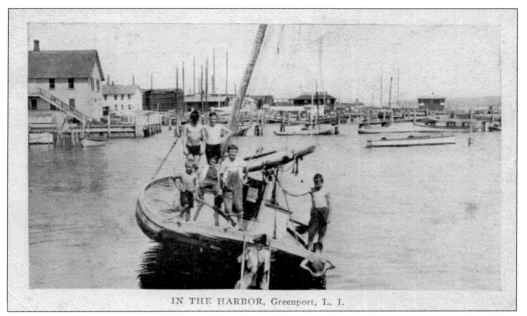

IN THE HARBOR, Greenport, L. I.

Boys will be boys, as the saying goes, and these boys play on and around a hard aground catboat. The photograph was taken in the vicinity of the extension of First Street to the waterfront. (SB.)

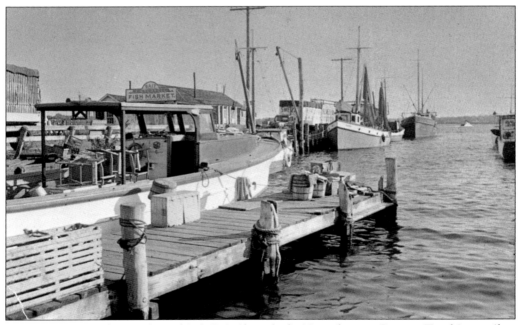

A party boat is tied up at the White's Bait Shop dock. Note the two Sweezy Trucking trailers on the left. Sweezy Trucking hauled fish from the Main Street Wharf to the Fulton Fish Market in New York City. (CDL.)

The *Zaida*, a 60-foot Alden cutter formerly owned by sail-maker George Ratsey, served valiantly in the Third Division of the Picket Patrol during World War II. Lost at sea for over 40 days, it was recovered and returned to her port in Greenport. Owner David Lish, a living history steward, has meticulously restored the *Zaida* and, through the Zaida Foundation, tells the boat's history in visits to several ports of call. The *Zaida* can frequently be found on the waterfront of Greenport. (DL.)

The *Fishcatcher* was a barge turned into a fishing motel. If one was looking for a few days on the water, the *Fishcatcher* offered him or her all the equipment for an excellent fishing trip, as well as a bunk and meals, so they could fish day and night. This unique party boat could be seen often on Peconic Bay during the early second half of the 20th century. (CDJ.)

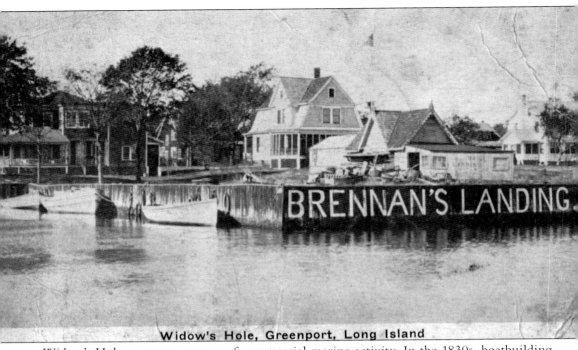

Widow's Hole, Greenport, Long Island

Widow's Hole was once an area of commercial marine activity. In the 1830s, boatbuilding increased in this area along with what is now known as East Main Street, on the area where the Greenport Basin & Construction Company now sits. The Brennan's Landing sign and work sheds show commercial marine activity. The area gradually became more residential as people developed a taste for waterfront living. (RW.)

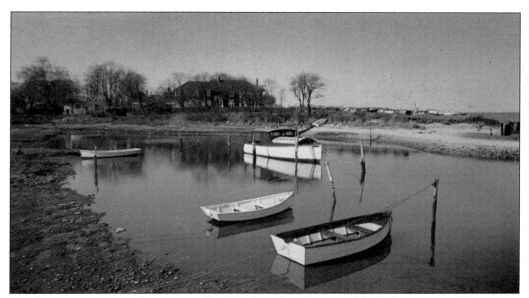

Rowboats rest in the calm waters of Widow's Hole. The spit of land that rises and disappears with the ebb and flow of the tides was once a continuum of the mainland; perhaps that is why part of the area's name is "Hole." This offers insight into why waterfront property owners in the area have underwater property rights. (SB.)

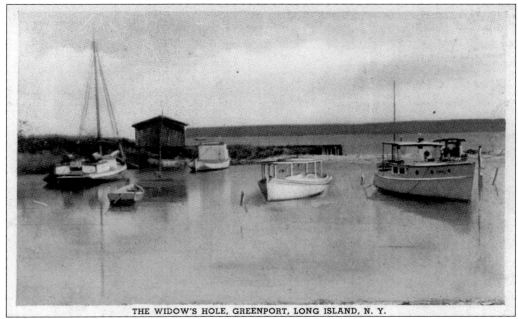

THE WIDOW'S HOLE, GREENPORT, LONG ISLAND, N. Y.

There is some argument concerning the appellation of the "Widow" part of Widow's Hole. It seems that long-standing residents of the area, lawyer Llewellyn Price and Walter Burden Sr., used to continuously debate the subject. One believed "Widow's" was correct, while the other claimed the real name was "Widder's." Widow's Hole is a waterfront residential area now, with two of its homeowners participating in the SPAT program. Their companies are called Widow's Hole Oysters and Greenport Oysters. (SB.)

This is the strong god hercules.
His mighty tasks he did with ease;
One yet remains; womankind to please.
The maid who kisses his mighty cheek
Will meet her fate within a week:
The one who praises his forehead
In less than a year will wed
No maid nor maiden ever taunted

Him with refusing what she wanted
Though hewn of wood and bound with tin
So all the gods he is akin,
And the spirits of them all
Hover over his pedestal
So whisper what you wish the most,
Fair maid, it's yours, and smell the rose.

The *Ohio* was launched as a new ship of the line in 1820. The ship had a varied, storied career but was decommissioned in 1850 and served as a receiving ship until it was eventually sold. After a second sale, it was towed to Greenport Harbor, stripped of the copper in its hull and of any valuable objects, and was then moved to Fanning Point, where oil was poured on the dynamite-laden hull. The ship was then torched. Sadly, the fireman who set the torch was killed in the blast. The Hercules masthead, which now adorns the Village Green of Stony Brook's lawn, was originally purchased for $10 and then sold for $15 and transported to Hampton Bays across the Montauk Highway from the Canoe Place Inn. (CDJ.)

Ten

ODDS AND ENDS

Some postcards have been hard to categorize but are too great to leave out of this book. This chapter includes a hand-drawn postcard from a local illustrator and inventor who drew many such cards, generally humorous in nature, to send to his friends. There was a scarcity of postcards of the local art community, long an important group in the Greenport citizenry, so there is a card announcing an exhibition of a prolific local artist in the mid-20th century. Seafood markets, a natural business in a waterfront fishing community, lacked representation in postcard collections, hence the image of a seafood market handout. Then there are the whimsical postcards advertising the lure of Greenport to tourists.

This boulder is adorned with a brass plaque that commemorates the visit of Col. George Washington. On his way to Boston, he spent the night in the Constant Booth Inn to await the morning boat to cross the Long Island Sound and continue on to his destination. (SB.)

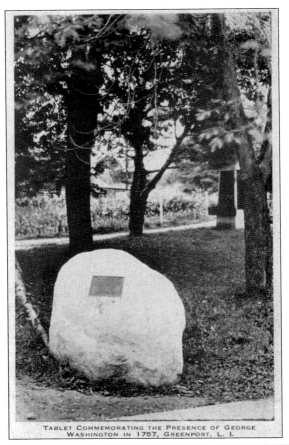

TABLET COMMEMORATING THE PRESENCE OF GEORGE WASHINGTON IN 1757, GREENPORT, L. I.

A waterfront like Greenport hardly requires advertising; talk of the natural attractions, marinas, restaurants, historic buildings, motels and hotels, and the authenticity of the village travels by word of mouth. Traditionally, however, postcards have been a source of advertising, and some of them take creative flights with their presentations, like the one seen here. (CDJ.)

Any fishing fan would certainly be lured to Greenport's shores by the size of fish in the waters portrayed on this whimsical postcard. (SB.)

Perhaps this early bathing beauty enjoying the surf would also lure those looking for fun in the sun to Greenport. (SB.)

WHITNEY M. HUBBARD

Greenport has always attracted artists. This postcard was the announcement for a Whitney Hubbard Retrospective in 2004 by the Village of Greenport Arts and Culture Committee. This show celebrated the variety and scope of Hubbard's work over the years he and his wife, Ruth, lived here. Whitney and Ruth supported themselves on their work and were a focal point of the arts in the area; she was a talented piano and organ player, performer, and teacher, and he was a prolific artist (his paintings, many on cardboard, now sell for handsome sums) who also taught and had a studio downtown. Today, the village, with the last mayor a talented musician and the current mayor a fine wood carver, brims with writers, musicians, and visual artists who thrive in this eclectic community that is supportive of all the artisans. (GFH.)

The presence of this old salt on the cover of the Greenport Fish Market handout that includes many delicious seafood recipes would certainly give assurance that all the seafood at the fish market is fresh. Today, long-standing Alice's Fish Market, located right on the shore of Stirling Creek, sells the local catch. (GFH.)

Frank Hartley, a local man of many talents, could be called a Renaissance man; he was an inventor and manager of an early Greenport telephone system and photographic equipment as well as a projectionist, humorist, photographer, and artist. Over the years, he created several, and often humorous, hand-drawn and photographic postcards, which he tailored to his recipients. Above is one of his hand-drawn cards. (CDJ.)

The address on this postcard is a perfect example of just how small a town Greenport was. This Hartley photographic postcard was actually delivered to its recipient. (CDJ.)

This souvenir is a reminder of the book's journey through the postcards of Greenport. Please return soon and enjoy some Peconic Bay scallops on the visit! (SB.)

BIBLIOGRAPHY

Booth, Antonia, and Thomas Monsell. *Greenport*. Charleston, SC: Arcadia Publishing, 2003.

Clavin, Tom. *Dark Noon, The Final Voyage of the Fishing Boat Pelican*. New York: McGraw Hill, 2005.

Corwin, Elsie Knapp, and Frederick Langton Corwin. *Greenport Yesterday and Today*. Mattituck, NY: Amereon House, 1972.

Fleming, Geoffrey, and Amy, Folk. *Hotels and Inns of Long Island's North Fork*. Charleston, SC: The History Press, 2009.

Hallock, Ann. *Old Southold Town's Tercentenary: 1640–1940*. Southold, NY: Southold Town Tercentenary Committee, 1940.

Shanks, Ralph, and Wick York. *The U.S. Life-Savings Service-Heroes, Rescues and Architecture of the Early Coast Guard*. Novato, CA: Costano Books, 2009.

Southold Town, Suffolk County, Long Island, New York, 1636–1939, The Oldest English Town in the State of New York. Commemorative book. 1939.

Village of Greenport 150th Anniversary Celebration Committee. *Anniversary Journal 1838–1988*. Southold, NY: Academy Printing, 1988.

ABOUT THE ORGANIZATION

The Stirling Historical Society of Greenport was organized in the late 1930s by Col. W.W. Burns. It was named after the First Earl of Stirling, William Alexander, who was granted the patent to the land comprising Long Island in 1621 by King James I. In 1976, a group of citizens met in the home of Fred and Elsie Corwin, the owners of the local newspaper, the *Suffolk Weekly Times*, and reactivated the society that had laid dormant for several years. In 1973, the society went into high gear when Mr. and Mrs. Fred Preston donated the Margaret E. Ireland House to the society as a home. After an intense fundraising drive, the house was moved across the Adam Street parking lot to the site of the esteemed Clarke House Hotel and restored, furnished and appointed as a late-19th century home with exhibit space. In later years, the society acquired the Berger House that was also moved nearby in the Adam Street parking lot and restored. Frequently used for exhibits, it is now being restored to house the archives of the Stirling Historical Society. It will also offer an appropriate place for people to research Greenport's rich history and to receive new donations of materials to expand the archive collection. All proceeds from this book will be used for this purpose.

DISCOVER THOUSANDS OF LOCAL HISTORY BOOKS
FEATURING MILLIONS OF VINTAGE IMAGES

Arcadia Publishing, the leading local history publisher in the United States, is committed to making history accessible and meaningful through publishing books that celebrate and preserve the heritage of America's people and places.

Find more books like this at
www.arcadiapublishing.com

Search for your hometown history, your old
stomping grounds, and even your favorite sports team.